Professional Press, Editorial and PR Photography

Professional Press, Editorial and PR Photography

Jon Tarrant

OXFORD BOSTON JOHANNESBURG MELBOURNE NEW DELHI SINGAPORE

Focal Press
An imprint of Butterworth-Heinemann
Linacre House, Jordan Hill, Oxford OX2 8DP
225 Wildwood Avenue, Woburn, MA 01801-2041
A division of Reed Educational and Professional Publishing Ltd

A member of the Reed Elsevier plc group

First published 1998

British Library Cataloguing in Publication Data
A catalogue record for this book is available from the British Library

Library of Congress Cataloguing in Publication Data
A catalogue record for this book is available from the Library
Congress

ISBN 0 240 51520 X

Typeset by Avocet Typeset, Brill, Aylesbury, Bucks
Printed and bound in Italy

CONTENTS

PROLOGUE

There are plenty of books already available about all aspects of photography, both professional and recreational. Why then is there now yet another dedicated to the world of press, editorial and PR (public relations) photography?

The answer to that question lies in the all-embracing title of this volume. Previous books have generally taken a much narrower view – a view that is no longer realistic given the ways in which this field of photography has changed in recent years. A staff position on a magazine or newspaper is no longer a job for life. Nor are there all the outlets for stills photography that once existed. The end of the twentieth century has seen a huge boom in moving pictures, with television now ruling the roost over which cutting-edge news photography once presided. Elsewhere, stock images have replaced assignments, and clients have become more willing to reuse old images rather than commission new ones.

On the other side of the coin, aspiring editorial photographers today seem reluctant to tread traditional, well-worn paths, but want instead to start at (or close to) the very top of the profession. This is simply unrealistic. It is depressing to count the number of budding photojournalists who say they want to join Magnum or pursue the kinds of picture stories that Tom Stoddart does so well. Even more depressing is the fact that many of those enthusiasts say they will give photography a go for a couple of years, and if it doesn't work out they will do something else instead. Whatever happened to commitment? Tom Stoddart didn't start out covering the war in Bosnia and life in Albania but, rather, was one of the pack who snapped Lady Diana Spencer when she was first linked to Prince Charles. He served his time in the tabloid arena and is now widely regarded one of the UK's foremost press photographers. But how many young photojournalists today are prepared to work as hard and as persistently to reach that level?

PROFESSIONAL PRESS, EDITORIAL AND PR PHOTOGRAPHY

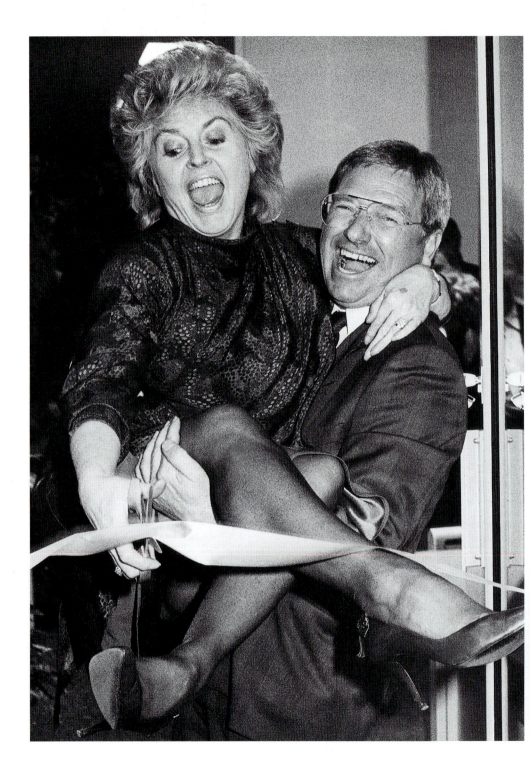

Figure 1.1 Gloria Hunniford, photographed in a lively variant on the 'cutting a ribbon' theme. This picture was taken for a local newspaper at the opening of a new estate agent's office.

Figure 1.2 Location fashion shoot for dress designer Caitlin Blair. Model: Anouska Fowler. Supplementary lighting was provided by a Lumedyne flash head fired into a brolly positioned camera right.

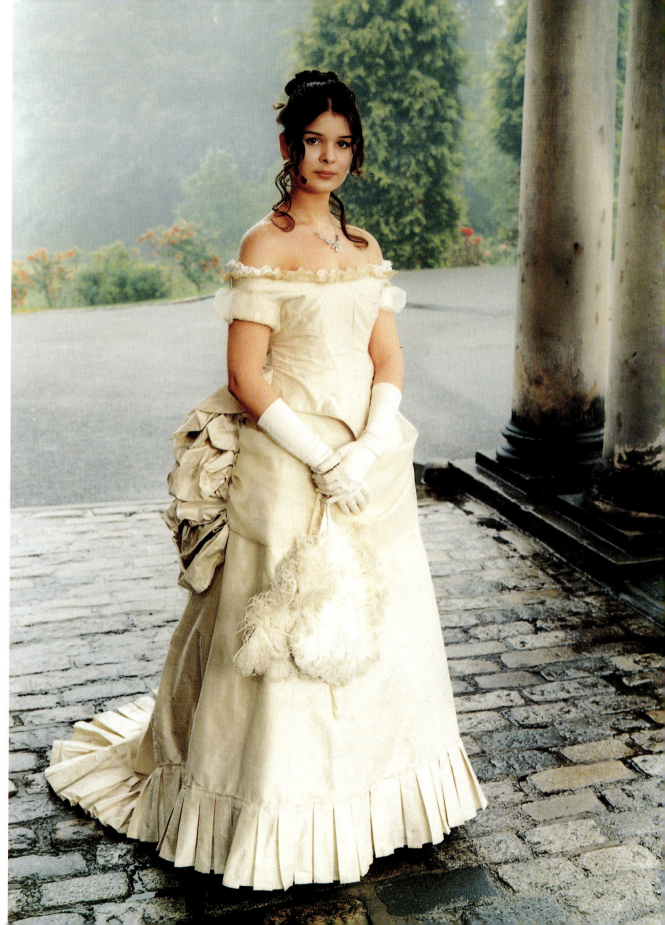

Another problem is the demeaning way in which PR photography tends to be regarded by those trying to break into editorial fields. Not only does this dismiss an entire area of work, but also it reveals a severely myopic view of the reality of newspapers and magazines, many of which are heavily reliant upon PR stories. Public relations photography is not 'the lowest of the low', but rather is one of the most honest areas in which to work. Everybody knows that PR pictures have a spin on them, and nobody pretends otherwise. This contrasts strongly with the reality of fast-breaking news events, at which press photographers are expected to get the most dramatic pictures possible – even in preference to those that are a more accurate reflection of the situation. Speed and drama are of the essence: in-depth picture stories are not what is required!

Other types of editorial photography assignments; be they celebrities at home, fashion spreads, magazine and book covers, historic national monuments, product pictures for consumer magazines or the secret lives of teenage holiday-makers, are frequently PR stories of one sort or another. The rare exceptions are the assignments that most editorial photographers long for but which few publications commission. Almost invariably, the most interesting types of pictures, especially picture stories, have to be undertaken by photographers on a speculative basis. To be fair, this is the way it should be: a good editorial photographer is not just a camera technician but also a source of ideas. Editorial photographers have to be committed to what they do, but they have to make money too. This balance is very difficult to achieve, and is certainly not helped by ignoring entire areas of work or by treating photography as something that can be tried for a couple of years then deserted for a more secure form of employment.

Whenever photographers of any sort are asked for advice about breaking into their own particular areas of work, they almost always give the most discouraging replies imaginable. This is due not to meanness or fear of competition, but rather reflects the fact that anybody who has to ask too many questions probably won't have the initiative to make it in the long run. The truth may not be quite as harsh as this belief suggests, but the future for young editorial photographers will hold many trials and challenges that only the most resourceful will be able to overcome.

Having said all this, it was my aim in writing this book to give some of the information that I wish I had known when I

Figure 1.3 The original picture used here was not commissioned by the magazine, but rather was taken as part of a model test session. The pose was deliberately exaggerated and the film (Kodak EPP) was cross-processed to give a more dramatic effect.

PROFESSIONAL PRESS,
EDITORIAL AND
PR PHOTOGRAPHY

5

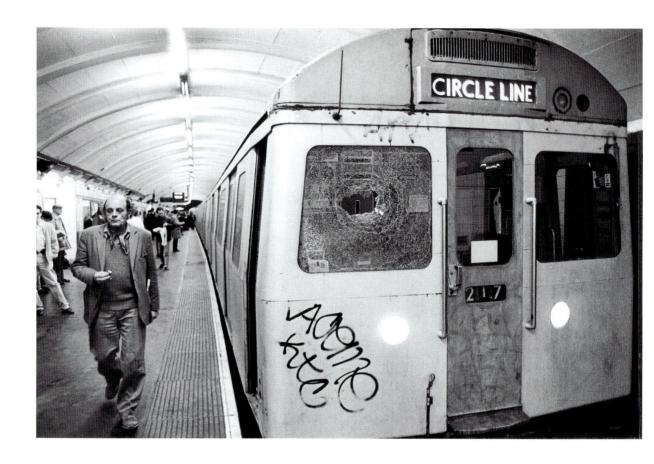

Figure 1.4 Vandalism and criminal damage, even to underground trains, is so common that pictures like this have little value unless somebody is killed or injured in the incident.

first started out myself. Inevitably, however, because I have written from the perspective of somebody who works in the UK, some of the details mentioned may not be applicable to readers in other countries. I can only hope that the general principles will come through in a way that will allow appropriate interpretation for different local situations.

2 INTRODUCTION

Press, editorial and PR photography is an exceptionally difficult area of activity to define. It covers everything from 'grip and grins' for local newspapers, to 'at home' celebrity portraits for glossy up-market magazines. Very often, but not exclusively, editorial and press photography is about people. The exceptions tend to be pictures taken for specialist publications or as part of PR assignments to promote particular products or companies. Even so, if there is a choice to be made between a picture of a machine alone versus one that also includes a photogenic person, then the latter will normally be favoured. An extreme example of this effect is the 'pretty girl with motorcycle' type of picture that adorns certain types of calendars, but the same principle also holds true very much more widely and should never be underestimated or overlooked.

Press, editorial and PR work can be commissioned either by the publication in which the pictures will appear or by a third party (such as a PR agency) that is directly involved with the subject in some way. Sometimes, pictures will be taken without having a specific publication in mind, but in the hope that they will be picked up when offered around. This is a particularly common PR scenario that forces the photographer to play picture editor too, guessing at which types of images are most likely to be successful. Successful pictures reflect well on their photographers, while unsuccessful ones can have a detrimental effect regardless of how easy or difficult the pictures were to take. Clients care little about the technical hurdles that photographers have to overcome, and very much more about the number of column inches their pictures occupy.

Because of all these things, press and editorial photographers have to be skilled in a wide variety of techniques. They also have to be adept at dealing with different types of clients, and at balancing the desires of one party against the

Figure 2.2 A typical mainstream PR picture that was also used in trade magazine advertisements. The clearly readable name on the front of the machine is crucial to the success of a picture such as this.

Figure 2.1 This portrait of pin-up girl Jo Guest was taken on a cold, gloomy day with rain spotting down. The film (Fuji Neopan 400) was pushed to accommodate the low light level.

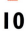

requirements of another (when the client and the publisher are not the same). It is the aim of this book to cover the full gamut of press and editorial photography, and to do so in a way that will benefit both those starting out in the field and those looking to improve their skills or broaden their areas of activity. The majority of the advice, techniques and solutions that follow are based on the author's own experiences undertaking assignments for national and local newspapers, trade magazines and PR clients. As such, the majority of the photographs used in this book are by the author. Where appropriate, this material is complemented by pictures and advice from other photographers working in similar areas.

What makes a good editorial photographer?

Technical ability is not the most important characteristic of editorial photographers. This is not to say it is unimportant but, rather, that there are other areas of photography – architecture, still life and advertising work, for example – where it has a higher priority. In editorial work, the photographer's personality and general approach are often the most important factors in determining how well he or she performs. Ultimately, the aim is to get the picture the client wants, which may not always be the best picture possible.

Because the range of assignments undertaken by editorial photographers is vast, so too is the variety of people who work in the different fields. It is fair to say, however, that certain types of characters are best suited to particular kinds of work. At the risk of over-simplifying human nature, what follows is a brief and at times tongue-in-cheek description of three character types and their most appropriate areas of editorial photography.

Gregarious extroverts are likely to be happiest in celebrity photography or working for aggressive PR clients. Such clients tend to be very dynamic, staffed predominantly by females (often young and/or power-dressed), are very much at home 'doing lunch' and frequently use unduly familiar or affectionate language. These same clients can also be the most fun to work with, offering the types of jobs that cause non-photographer friends to ask 'what is so-and-so really like in the flesh?'

Photographers who work in this area need to be smartly dressed and comfortable with the idea of promoting people and/or products to a level that is determined not by their intrinsic value but by the client's marketing plans. Make no mistake, this area of photography can bring fame and fortune,

Figure 2.3 Christmas pantomimes are regular photo-call events that are covered by local and national press photographers alike. A useful tip is to concentrate on smaller groups because it is easier to get everybody to look towards the same camera when there are fewer people whose attention you need to attract.

but it is not for those who seek to change the world with their pictures.

Very outgoing photographers are likely to perform less well doing portraits of company directors or others who command respect – and who expect to be treated accordingly. It is simply unacceptable to behave familiarly with senior business managers you have never met before. Business assignments are likely to be undertaken on behalf of trade magazines, industry-related PR agencies and manufacturing or service companies themselves. Those who work in this field need to have a feel for business and be well turned out, though in a rather more conservative manner than is appropriate for trendier clients.

It is a simple fact of life that people respond best to others who are like-minded. Because of this, it can be useful to develop a feeling for the prevailing mood or atmosphere of a situation. Photographers who have this knack are chameleons who can blend in and win confidences when others find their

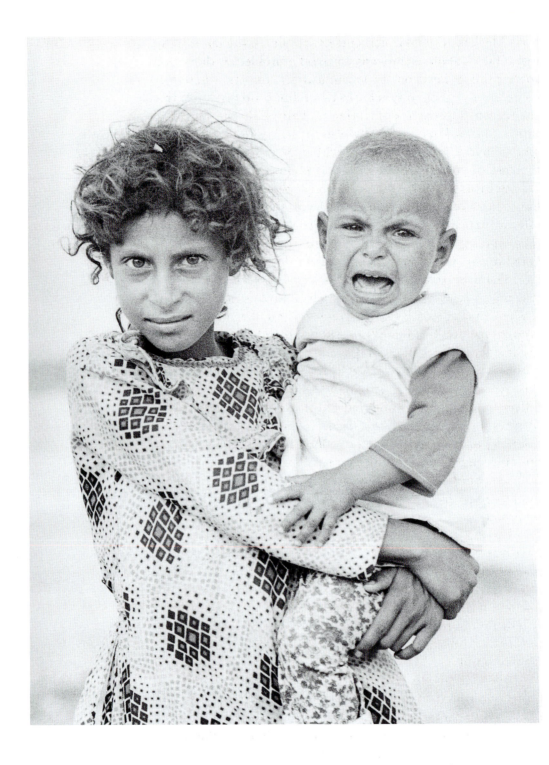

Figure 2.4 In 1982, I went to the Israeli-occupied Gaza Strip to photograph the Palestinian refugees who live there. This picture is taken from that series: I often wonder what became of these two children.

ways blocked. Chameleons tend not to play on being a photographer, and often find ways around a problem rather than confronting it head on. In an industrial situation where the scene to be photographed needs a little tidying up, the chameleon approach is to offer to help with the cleaning rather than asking somebody else to do it. The language is more about requesting a broom with which to sweep the floor than asking somebody else to do the job for you. Significantly, in both cases it is likely that somebody else will do the tidying, but at least you will have identified with those around you by offering to help. Having said this, participation must never be taken to the point of recklessness, and should always be tempered by your own abilities and knowledge.

The third type of character is somebody who is meticulous and who wants to have as much control as possible over the pictures taken. Such people verge on the advertising/architecture/still life edges of editorial photography. Technical quality is more important here than it is elsewhere, and is often recognized as such by clients who commission this type of work. Unfortunately, editorial budgets rarely reflect the amount of time and effort needed to capture the pictures to the desired standard. Clients tend to produce examples of advertising images and ask for something similar, but only want to pay editorial rates. More than any other area of press and editorial photography, this is where money matters must be fully agreed in advance of any work being undertaken.

Having sounded this note of caution, clients who have a realistic view of what is possible can be very satisfying people for whom to work. Often, such assignments are the most creative because there is no detailed brief and no looming deadline to meet. All that is asked for is 'an attractive picture of the floor' or 'a nice picture of this pot of paint' to supply to a trade magazine or for use on an exhibition display stand.

There is also a fourth character type; the observer – somebody who deliberately stands outside whatever is being photographed and maintains the air of a stranger. This attitude tends to restrict picture-taking opportunities rather than improve them, but in some areas of activity it is inevitable. If an assignment takes you into a community whose language you cannot speak, then you are very unlikely to be regarded as anything other than a stranger. This said, those who set out deliberately to cultivate the air of a detached observer,

13

recording absolute 'objective' pictures, are simply being naive: photographs of strife and suffering, which are those that 'objective observers' most often seek to record, are bound to have an effect on those who view them. As such, they must surely have an effect on the photographer too, and once a photographer has been affected, that person is no longer an objective observer.

Don McCullin, writing in his retrospective book *Sleeping with Ghosts* (Vintage, London, 1995), summed-up the reality of photojournalism very succinctly. 'Photography for me,' he observed, 'is not looking, it's feeling. If you can't feel what you're looking at, then you're never going to get others to feel anything when they look at your pictures.'

3 CAMERA EQUIPMENT

Photographers sometimes say that equipment doesn't matter; that it is the person who takes the picture not the camera. This is total rubbish. Anybody who says otherwise is invited to leave their cameras behind when going on their next assignment, or to take only a fixed-focus compact to photograph motor-racing, or a medium format camera to do door-stepping. It is a fact that the equipment chosen has a significant impact on the kinds of pictures that can be taken, and that sophisticated 135 format SLR (single-lens reflex) cameras are the most appropriate choice for the vast majority of newspaper-related photography.

This said, there is a great cautionary tale that can be told about the return to the UK of former hostage Jack Mann. When Mr Mann stepped onto the tarmac at RAF Lyneham, his arrival was welcomed by the RAF base commander, by Foreign Office minister Douglas Hogg MP and by a host of newspaper photographers. As the men approached each other to shake hands, the motordrives whirred – but many of the pictures taken were out of focus to one degree or another. The reason was that the cameras had focused on the centre of the picture area – the gap between the figures! This problem is unlikely to arise now thanks to wider-base, more intelligent AF systems, but even the best equipment still makes mistakes. Alert photographers are less likely to make the same errors, but have to work harder to avoid them. Inevitably, nothing that is worth having comes easily.

In other areas of editorial photography, 135 format SLRs are not always ideal. This is partly because larger cameras are more imposing and can command more respect, and partly because most larger models offer Polaroid facilities that improve reliability and add to the photographer's air of professionalism. But perhaps most important of all, larger format cameras can yield better quality images and help to justify the charging of higher day rates.

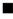

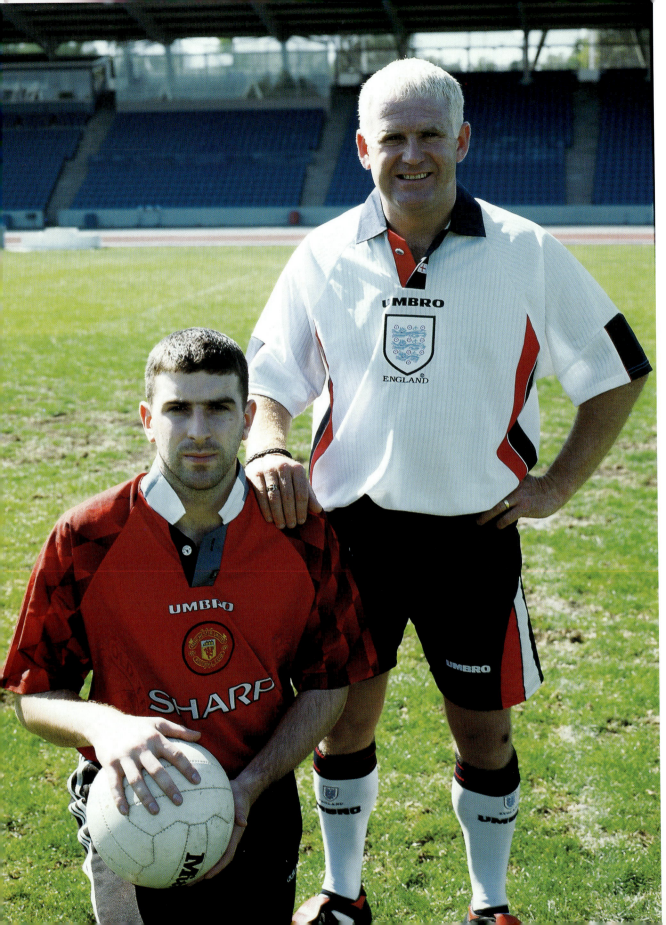

135 format SLRs

In the UK, press photographers tend to choose Canon cameras in preference to everything else. This is not because Canon's cameras have the best AF systems, but rather because the company was the first to embrace a new style of ergonomically designed, high-performance bodies. It also happens that Canon's USM AF lenses are very fast, very quiet and yield high-quality images. But, if truth be told, there are frequent occasions when autofocus is not used, including many high-speed sports situations where casual observers tend to assume that quick-reacting AF lenses are *de rigueur*.

Photographers who choose non-Canon cameras tend to do so because they want an all-mechanical back-up, which Canon's range does not have. In the case of Nikon, there is the tried and trusted FM2. This is an exceptionally well-built, rugged camera: even its FM forebear (which can be picked up quite cheaply secondhand) is both tough and reliable. There is also a good supply of secondhand manual focus lenses, though Nikon's AF lenses are equally compatible with its all-mechanical bodies.

On the subject of lenses, it is worth noting that many independently manufactured optics are capable of producing top-class results that are indistinguishable from those taken on camera manufacturers' own lenses. The best guide to lens quality is no longer the name on the front, but the optical specification and price of the item concerned. Amongst the top UK press photographers who use independent lenses are Paul Stewart (who is a great fan of Tamron's SP range, especially the 24 mm f/2.5) and Roger Bamber (who uses a Sigma 14 mm full-frame fish-eye – no such lens being offered by Nikon itself).

Other camera marques that are worthy of serious consideration include Olympus, Contax and Minolta. Olympus equipment was once the favoured choice of many travelling photojournalists on account of its light weight. Later, Olympus cameras became the first to feature integral spot metering, and today's models are still remarkable for their

Figure 3.1 **Look-alike footballers photographed for their agency, The Sports Workshop. The picture was taken on Fujichrome Astia transparency film on a very bright, sunny day: fill-in flash was used to throw light into the sportsmens' eyes.**

Figure 3.2 Canon EOS-1N.

Figure 3.3 Nikon FM fitted with a Russian-made perspective control lens.

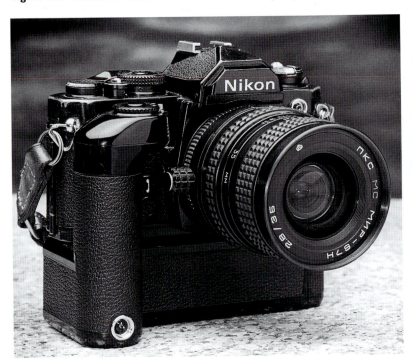

sophisticated exposure evaluation systems that remain unmatched by other manufacturers.

Contax's primary benefit is its use of Carl Zeiss lenses. The significance of this point can easily be underestimated by those who have not seen what a Carl Zeiss lens can do. Personally, I have never seen sharper results from a 135 format SLR than those I got from the Planar 100 mm f/2.8 that I once tested.

Minolta is easily overlooked in the UK – less so in the USA – as far as professional use is concerned. Largely, this is due to the way in which the cameras are marketed, for the truth is that Minolta's top cameras are easily up to professional use. The company even has a dedicated line of professional lenses. Against this, and in common with Olympus and Contax, there is very little support for professional users at major UK press events – where Canon and Nikon are often strongly in evidence thanks to their overwhelming popularity. Generally speaking, it makes sense to go with the flow.

My own choice to use Nikons was made twenty years ago. At that time Nikon was the marque everybody recognized as *the* professional system (though Canon was already trying hard to swing opinion in its own favour). If I had to choose a 135 format system today, the outcome would not be the same. That is not to say there is anything wrong with Nikons, but rather is an admission that my own priorities, and the equipment market itself, have changed. Individual readers must assess these things for themselves and choose accordingly.

6 × 4.5 cm SLRs

Despite their relative lack of sophistication, 6 × 4.5 cm cameras can still be better choices than 135 format models for certain types of editorial work. Modern 6 × 4.5 cm SLRs tend to have about the same specifications today as 135 format models had about fifteen years ago. Their ranges of shutter speeds are similar, as are their metering systems. On the other hand, the medium format film size is bigger, film-changing is much quicker (using preloaded interchangeable backs) and there is the ability to take sensible size Polaroid pictures. Significantly, 6 × 4.5 cm camera prices are not dissimilar to those of modern miniature cameras.

There are three 6 × 4.5 cm SLR systems, one of which now offers AF operation for the first time on an interchangeable lens medium format body. A word of caution, however:

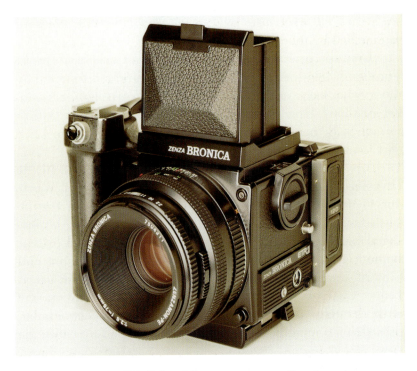

Figure 3.4 Bronica ETR-Si 6 × 4.5 cm compact medium format camera.

Figure 3.5 Hasselblad 501CM, a recent incarnation of the longest running fully compatible medium format SLR camera system.

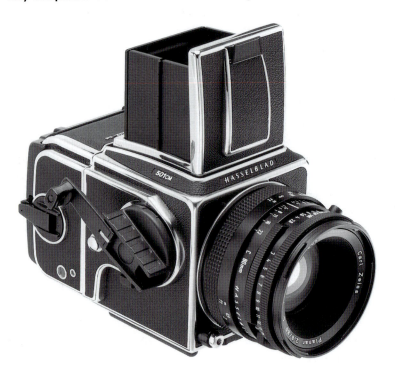

experience shows that it is generally best to avoid the latest technologies until they have had a chance to prove themselves. On the other hand, and as with digital cameras, if you take the plunge straight away and all goes well, then the new technology can give you an edge over other, more conservative, photographers.

Bronica's and Mamiya's 6 × 4.5 cm systems are similar in that they both offer a good range of interchangeable lenses, various film holders (including Polaroid backs) and TTL (through-the-lens) flash control. Ultimately, the only way to choose between the two is by holding both cameras and deciding which one feels the nicer. There are well-respected photographers in both camps, so individual recommendations can be no indicator of superiority.

The third possibility is the Pentax 645, which has always been very much more sophisticated and is now even more so with the advent of the Pentax 645N autofocus model. The only disadvantage of the Pentax system is that it is rather less flexible, lacking the ability to use a Polaroid back or to change films mid-roll. But if these things are less important, and the camera is being used as an oversized 135 format model rather than as a compact but still fully versatile medium format system (which is how the Mamiya and Bronica are best viewed), then the Pentax 645N is an excellent option. Be sure, however, to handle and use the camera before making a final decision. If possible, hire a small outfit and test it in the field: if necessary, hire all three models before making your choice.

Larger roll-film SLRs

There is a slight tendency for 6 × 4.5 cm (six-four-five) cameras to be regarded as a compromise: they are not as small and sophisticated as miniature models, but nor are they as imposing as something bigger. There is a degree to which this evaluation is correct, but a single six-four-five system will definitely cost less than the other two combined – and will still meet many of the needs addressed by the two separately.

When something bigger really is needed, the question that then arises is which format is best; six-six, six-seven, six-eight – or something entirely different? As far as six-six is concerned, one of the most persuasive factors is the square format's exceptional cropping flexibility – provided that the picture isn't framed too tight. Beyond this, deciding between the three front-runners is mostly a matter of budget and styling preferences.

■

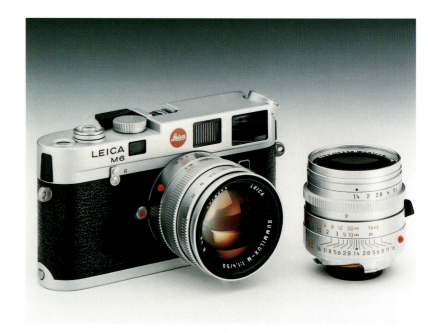

Figure 3.6 The Leica M6 is highly respected for its quiet operation and for the outstanding quality of its lenses.

Figure 3.7 For times when image quality is paramount but the weight and bulk of the equipment carried must be kept to a minimum, the Mamiya 7 medium format rangefinder camera, with its interchangeable lenses, is very hard to beat.

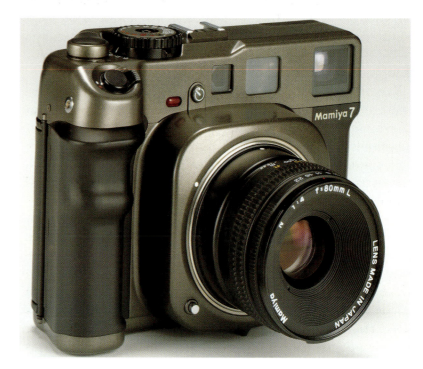

Hasselblad traditionally has the edge over Bronica and Rollei simply because it has become so well established in the market. Bronica's cameras are cheaper than Hasselblad's, while Rollei's are more expensive. Bronica and Hasselblad favour the dumpy square shape, but Rollei uses a more upright design that is derived from its twin-lens models of old. Rollei is the only manufacturer to offer its own digital backs, but independent suppliers do support Hasselblad bodies: there is less digital support for Bronica cameras.

But before getting too bogged down with the relative merits of different square format cameras, it is important to consider whether or not a rectangular format would be more appropriate. Bronica offers a 6 × 7 cm body as well as its 6 × 6 cm model, and Pentax has what can only be described as an oversized 135 format SLR. But the kings of the six-seven format are Mamiya's all-mechanical RB67 and the electronic RZ67. The former has acquired a reputation as a 'Hasselblad basher' in all applications except digital imaging – where the RZ67 is very well supported.

Fuji's GX680 shares Mamiya's bellows focusing system (which allows tighter than normal framing without any need for extension tubes or close-up filters). In all other respects it is very different, being a significantly bigger camera that incorporates perspective control movements and a very clever multiformat film holder. Although there are editorial photographers who use the GX680, for many it is simply more than their demands require.

Rangefinder cameras

All of the preceding comments have concerned SLR cameras. It is true that these are the most popular choices for editorial photography, but three other systems do deserve special mentions; the Leica M6, the Contax G2 and the Mamiya 7. All are rangefinder models that have built admirable reputations on the exceptional quality of their lenses. The great black and white printer Larry Bartlett used to say that he could always spot a negative taken on a Leica M6 by virtue of its delicate shadow detail and high sharpness. My own opinion is that pictures taken on the Mamiya 7, especially when using its standard lens, are sharper than those taken on any medium format SLR. The reason for this, and for the unique quality of Leica M6 images, may well be due to the fact that the lens designer is not impaired by having to accommodate a mirror box between the rear element and the film plane, and so is

able to avoid the compromises that would otherwise be inevitable. The Contax G2 goes one better in that it features automatic focusing (with manual override), making it very nearly as quick and easy to use as a simple point and shoot compact, yet with all the quality of a top-of-the-range professional system.

Lenses

The special quality afforded rangefinder systems leads neatly on to the subject of lenses in general. The basic kit for any camera should include a standard lens, a wide-angle that is about two-thirds the standard focal length, and a longer lens that is about twice as long. For 135 format cameras, the set typically comprises 35 mm, 50 mm and 85/105 mm lenses – or a single 35–70 mm zoom. Often, this zoom will be complemented with a second one covering 80–200 mm. Both should be fast, constant aperture designs. Significantly, such zooms are included in all the top manufacturers' AF ranges.

Commonly, medium format cameras have a standard lens focal length of around 75–90 mm regardless of picture shape and size. The wide angle lens is typically 65 mm, while the longer lens is around 150–180 mm. If budgets are tight, one or both of these lenses can be hired when required. This said, it is vital that they *are* hired, and aren't simply forgotten about. One of the foremost aspects of professionalism involves always turning up for a job with the right equipment. Nobody is to know whether you own it or not, and the cost of hiring can be billed to the client (surreptitiously if necessary). Whatever tactic is employed, the most important thing is that all the appropriate items are to hand when they are needed.

Beyond the core lenses, other focal lengths should be purchased (or hired) as work demands. A fast long focal length lens, such as a 300 mm f/2.8, can prove useful for everything from fashion to sports, but is quite cumbersome to carry around. Modest aperture lenses are more convenient and less costly. Extreme wide-angle lenses can be very useful for close-quarters news photography and also for environmental portraits.

Finally on the subject of lenses, it is important to stress that the lens is normally the thing that has the greatest effect on picture quality. By definition, good lenses produce better pictures than bad ones. To maintain image quality, lenses should always be handled with care. They should have protective front filters and be fitted with front and rear caps.

Even so, it is a fact of photojournalistic life that lenses do get abused, and they should therefore be regarded as items with fixed lifetimes. Although camera manufacturers sometimes make much of lens mount compatibility between different generations of cameras, the wise photographer budgets for major lens servicing and periodic replacement of his or her most heavily used items. Old lenses that have sentimental value can be retained, but important fee-paying jobs should not rely on them to yield the sorts of top-quality results that can be produced by new or fully reconditioned lenses.

Digital cameras

Although the reality is that the vast majority of press photographers – let alone editorial photographers in general – do not use digital cameras, electronic systems do play a crucial part in certain aspects of newspaper work. In particular, digital cameras allow pictures to be taken and transmitted more quickly than is possible using any film system. At times when the first picture on the editor's desk is the one that gets used, digital photographers clearly have a huge advantage over those who use non-digital cameras.

Tempering this benefit are reasons why digital cameras are not more widely used than they are. The first is high cost – bearing in mind that a photographer should ideally carry not just one but at least two camera bodies. The second is the fact that film is a nicer medium with which to work. Tying these considerations together is the fact that deadlines are rarely so tight that digital is the only option. It is far more common for 'digital photographers' to take pictures on film then to scan their images for transmission – a route that combines the best of both technologies.

As far as digital cameras themselves are concerned, advances are currently taking place at such a rate that it is difficult to be specific about individual models. In general, and despite price reductions in excess of 30 per cent during 1997 alone, the most capable digital cameras for serious press use still cost around £10,000 each. Below this figure, digital cameras tend to have fixed lenses and/or lower resolutions. For some applications they will be sufficient, but such models cannot be recommended to a newcomer as a sensible investment for general editorial photography. In addition, the vast majority of clients still expect to be able to receive pictures as transparencies or prints under normal circumstances. Without doubt, the best tactic is to monitor the progress of digital

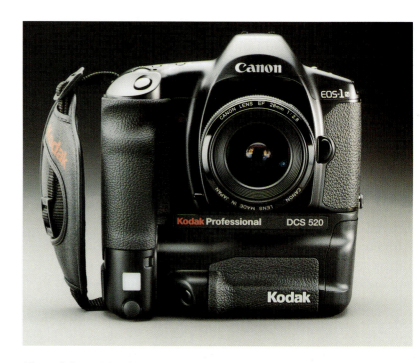

Figure 3.8a and b At the time of writing, Kodak's DCS 520, shown here, is the most sophisticated digital camera currently available for press work. It is based on a Canon EOS-1N body and is capable of producing 6 MB picture files. In addition, it has a small LCD image preview screen, a fifteen-frame 3.5 fps burst rate, a removable battery pack and a specially calibrated TTL flash system for improved exposure accuracy. The current price is almost exactly £10,000.

cameras through an august medium such as the *British Journal of Photography* and to attend to the needs and wishes of your own clients.

Significantly, using a digital camera is much the same as using a film camera. Indeed, most digital cameras are nothing more than modified film bodies. Certain limitations exist at present, such as the inability to shoot for extended periods of time in motordrive mode, but these things will surely be overcome in the future just as image quality has already been improved to date. The most important difference between film and digital cameras lies simply in the fact that it is necessary to be computer literate if you are to get the most out of an electronic system.

It is important to note, however, that digital cameras are totally dependent on battery power for their function. This fact is also true of many film-based cameras, and of other items such as flashguns. Because so much can hang on the battery's performance, it is essential that this area is given full consideration when buying items of equipment. Few serious press and editorial photographers would buy a flashgun that could use only standard battery cells and was not supported by high-performance battery systems. The same is often true of film cameras, where external power supplies or bolt-on boosters are added for superior performance. So it is now with digital cameras. At the time of writing, manufacturers of the best stand-alone battery systems (Lumedyne and Quantum) are developing sophisticated new power supplies that will be ideally suited to digital cameras. The fact that these new units will also offer superior performance when linked to camera flashguns is an added bonus.

Other accessories

There are only really three types of accessories that are essential. These provide illumination, support and a means of carrying everything around. Additional items, such as remote releases, can be very useful in particular situations but need not form part of the core equipment list.

Illumination, in this context, is almost invariably the light provided by a battery-powered flashgun. All the major camera manufacturers have their own flashgun systems, and it is fair to say that these tend to be the models that take maximum advantage of individual cameras' capabilities. Independent flashgun manufacturers, such as Sunpak and Metz, tend to offer a greater choice of models and power levels

– sometimes at better value for money prices. In addition, Metz, through the SCA (special camera adaptor) interface system, allows its flashguns to be dedicated to a wide range of cameras, both 135 and medium format.

Personally, I have used Nikon, Sunpak and Metz flashguns, and would choose between them differently depending on the job in hand. For ease of use and maximum sophistication, the camera manufacturer's own flashgun is the sensible choice. For heavy use, it should be complemented with one of the aforementioned high-capacity battery packs. For medium format photography, I would use a Sunpak or Metz flashgun that is more versatile when used in the absence of TTL flash metering. In this case, when heavy use is only occasional, additional battery clips are often a more economic alternative to a high-capacity pack. It is also worth noting that Lumedyne and Norman flash systems can also be employed as on-camera flashguns, though they are actually very much more powerful (and less sophisticated) than is usual for this particular use.

Camera supports are often tripods in non-news situations, and monopods otherwise. Equally important is a support that elevates the photographer as well as the camera. This can be nothing more than a hard-bodied equipment case on which to stand, but sometimes it takes the form of a small ladder. Certainly, press photographers should always have a small set of steps in the boot of their cars.

As far as tripods are concerned, it makes sense to have two of different sizes. The smaller, lightweight model should be a Manfrotto 055 or similar, while the larger one should be something more rigid, such as the Manfrotto 075. To mount both miniature and medium format cameras, it will be necessary to have different tripod screws, one in 1/4 in size and the other in 3/8 in. Alternatively, both sizes can be accommodated with a single 1/4 in screw if a conversion thread is inserted into the larger diameter camera mounting – though this is not as secure as using a bigger screw.

Monopods are ideal when space is at a premium and are also very much more portable than tripods. They are especially useful when using long lenses because they take all the weight and therefore allow the photographer to concentrate on taking pictures. It is often the case that monopods seem rather expensive for what they are, but they do last almost forever.

Billingham bags were once the standard choice of press photographers, and remain very popular for containing everything in the boot of a car. Often, however, items will be

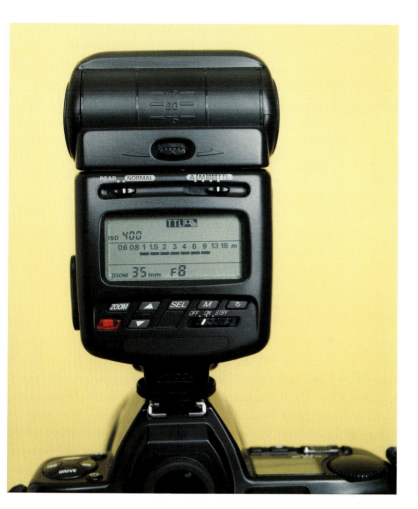

selected from the big bag and put into a smaller one, or into the pockets of a photographer's jacket for easy access when working.

Away from the press arena, hard and soft cases are both popular. The former are more appropriate to larger items such as medium format cameras and long focal length lenses, but the latter are generally more comfortable to carry. Another important difference between the two is the way in which they are packed. Hard cases tend to be filled with equipment, while soft bags are normally left with a fair bit of spare room inside. This is partly in recognition of the fact that items sometimes get dropped back into the bag without being slipped into their proper places, partly because when items are assembled they always take up more room than they do separately (the prime example being a flashgun fitted on top or to the side of a camera) and partly it is to allow room for changing lenses out

Figure 3.9 The best flashguns have simple, uncluttered control panels that enable the mode set to be checked quickly and with a minimum of fuss.

of the sight of prying eyes or protected from inclement weather.

Whatever type and size of bag is chosen, the important thing to remember is that it will be all that keeps the equipment from being damaged or dirtied when out on assignment. As such, it makes sense to buy the very best possible. In addition to Billingham, names to look out for include Tamrac, Domke, Fogg and Pelican. Within these ranges, and those of other top-quality bag and case manufacturers, there is enough choice to provide the ideal carrier for every application and size of outfit.

It is likely that you will need at least two bags; one to take everything and one for a reduced kit. For maximum convenience, there ought to be separate bags for each different camera format that you use, though it should be sufficient to buy one all-purpose bag initially.

As usual, don't make any final decisions until you have tried a range of different manufacturers' designs. Some people like the soft body-hugging feel of Domke bags, while other people dislike their lack of rigidity: the same is true in opposite for most of Billingham's bags. Weatherproof overcovers sound like a good idea, but because they hinder access they are of only limited value. It is better for a bag to have good inherent weatherproofing than to rely on additional barrier layers. Similarly, zips are more secure than fold-over flaps, but are not as easy to operate one-handed. Never try to assess a camera bag with it resting on a camera shop counter: always put it over your shoulder, preferably filled with your own equipment, before deciding whether or not to buy. The right

Figure 3.10 Billingham's camera bags are long-standing favourites with press photographers. In recent years, the company has also started offering smaller models to complement its range of cavernous designs.

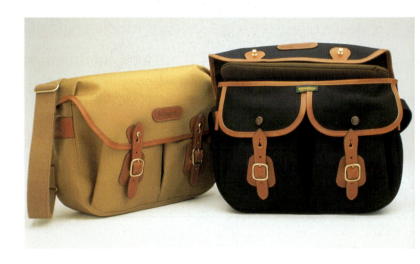

Figure 3.11 It is always worth keeping in mind that there are a number of non-standard film formats that can be especially well suited to particular types of pictures. The photograph here was taken using a Fuji 617 panoramic camera loaded with Agfa Scala 200 black and white transparency film.

camera bag will be a joy forever. The wrong one will be, quite literally, a pain in the neck.

Compacts

No matter how small and how comfortable your camera bag is, there will always be times when it is simply too bulky to carry. Unfortunately, one of the worst things that can happen to a photographer — especially somebody who works in the press arena — is to witness an event that would make a great picture but to be caught without a camera. The way to avoid this problem is always to carry a camera of some sort. This much is readily appreciated, but people sometimes overlook the fact that a 'go-everywhere' camera must be rugged, very quick to use and, ultimately, expendable. In general, a top-quality compact will be a better choice than a Leica M6 in this context.

It is difficult to generalize about the best compact camera to choose, but the important things to consider are lens quality, degree of automatic exposure and focus sophistication, accuracy/range of film speeds and camera settings, manual override facilities and overall ease of use. Possible contenders at the time of writing are the Konica Hexar, Ricoh GR-1, Contax T2 and Minolta TC-1. A good zoom lens alternative is the Contax TVS. In all cases, it is very important that the film loaded is appropriate to the types of pictures you are likely to want to take: an ISO 400 colour negative film will probably give the best balance of market potential and image quality, but if you happened to snap a picture of Lord Lucan trotting past on the back of Shergar, nobody would care what film it was on. Fishermen can regale audiences with stories of 'the one that got away', but for a photographer to tell such a tale is to admit professional incompetence. Never let this happen to you.

4 STARTING OUT

Originally, this chapter was to have been entitled 'Setting up in business', but the odds are that a number of readers would have skipped it. This fact is a sad, but horribly accurate indictment of many photographers' attitudes to financial matters. Those who are well established in the profession often say two things to newcomers, neither of which the latter seem to want to hear. The first is that professional photography has to be a commercial business just like any other if you are to succeed in it. The second is that nobody should ever become a full-time professional photographer simply because he or she likes taking pictures.

The advice these gems contain provides the fulcrum on which the lever of long-term success operates. People can be fearfully unhappy doing jobs they hate, but tend to be every bit as disgruntled not having enough money to buy the week's food. If a job has sufficient long-term potential, then short-term sacrifices may be justified, but this is not a sustainable situation. Businesses have to make money – that is their primary function. The amount of money required depends on what any given individual wants and needs, though it is also a fact that somebody's success in a particular area is often measured by his or her material possessions; a nice house, a luxury car, exotic holidays. So it is that even if you don't necessarily desire all these things, you may find that having them leads people to think more highly of you, and even to favour you when it comes to assigning work. Public and professional recognition counts too, of course, but these things are rarely divorced from commercial success. In short, if you want to succeed in photography, you must also succeed in business.

First steps

There are people who think that all it takes to be a photographer is possession of a camera. This is wrong on two counts.

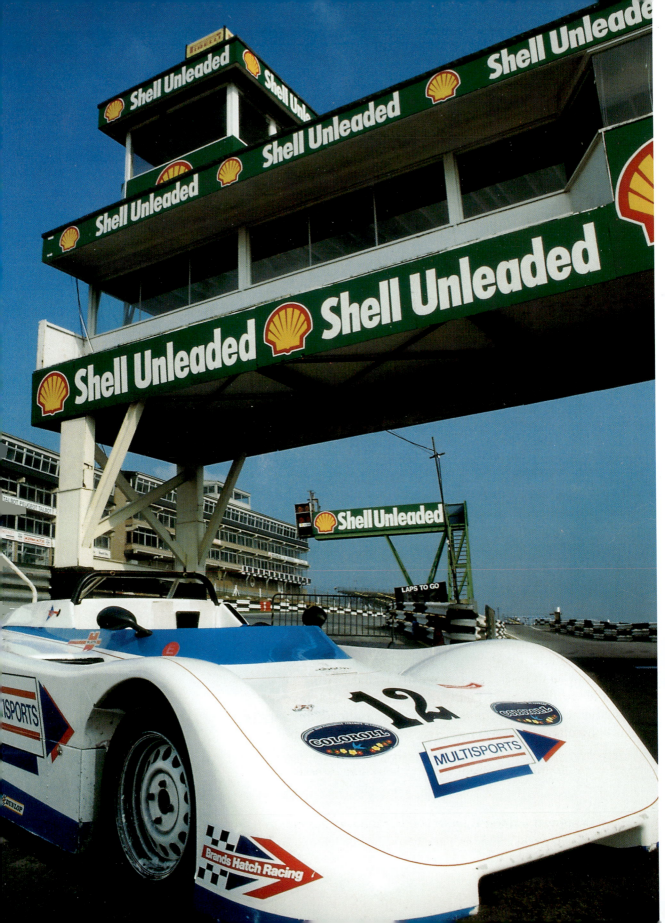

The first is the unlikelihood that any casually owned camera kit will be sufficient for professional work; the second is the overriding importance of a clear business plan. Equipment has already been discussed in part in Chapter 3, and will be covered again in the next chapter, leaving the rest of this one for financial and commercial issues.

Before embarking on any business venture, it is important to have a plan. This needs to cover projected cash flow, sources of work, funding and performance targets. The first of these is pure speculation, but is absolutely essential nevertheless. The second and third should be concrete and well researched. The last is a measure against which the others can be evaluated – though you should have a 'gut feeling' for how things are going without recourse to predetermined targets.

Excellent advice on matters financial can often be obtained from the small business advisers at major high street banks. It is tempting to think of banks only as places where you go to borrow money, whereas in fact they should also be viewed as financial experts whose skills can be drawn upon free of charge. Most banks have information packs and will happily talk you through the intricacies of business planning. Although their staff are not well versed in such things as tax and VAT, the Inland Revenue and Customs and Excise are very helpful here in their own respective areas of activity. If you choose to use an accountant, all this expertise will be available under one roof: the disadvantage is that you will have to pay for this convenience. On balance, it makes sense to get expert advice when you first set up in business, so you should seriously consider finding an accountant as quickly as possible, even if you subsequently dispense with his or her services once you are established and confident in correct business practices.

Projected cash flow is one of the things that banks always want to know about – and is also a crucial factor in the likely success of any new business. A template for calculating projected cashflow is normally included in banks' small business information packs, but in the absence of such a form all you need do is to list all the things on which you spend money; rent (or mortgage), food, vehicle expenses, fuel bills, insurance premiums, TV licence, mobile phone account –

Figure 4.1 This picture was specially set up in the pit lane at Brands Hatch to provide the cover for a leisure magazine.

Figure 4.2 Portraits of managers tend to divide into formal and candid types. The former (above) are very much easier to execute because all elements are under the photographer's control. The latter (below) tend to be more cluttered and might well benefit from electronic retouching if time and the budget allow.

Figure 4.3

Figure 4.4 'Street style' candid photography is something that many students think plays an important part in professional press and editorial photography. In fact, images such as this have very little commercial value.

everything that costs you money in a year. The easiest way to get a reliable list of these things is to go back through your previous year's bank statements and cheque-book stubs to see where your money went. Those items that are not monthly outgoings need to be added up and divided by twelve to obtain an average monthly figure that is then added to all the actual monthly expenses. The total obtained is your monthly overhead.

This figure may not be perfect because things do tend to get overlooked, but it will provide a *minimum* on which to work: only very rarely indeed do people calculate monthly overheads that turn out to be overestimates. If nothing else, you are likely to be surprised by such things as the increase in your telephone bill, postage or the cost of getting stationery printed – none of which are taken into account by the historic overheads calculation. The other thing to watch out for is the coincidence of extraordinary expenses that are averaged out as part of the mean monthly figure. One common occurrence

concerns motoring expenses: car insurance, road tax and the annual MOT inspection often all fall at around the same time. If that time is early in your trading year, then you may not have enough funds available to pay all the bills. Rather than trying to anticipate all these things in detail (which you never will with 100 per cent success), it is better to build a safety margin into your monthly overhead figure to help guard against such unfortunate occurrences.

The income that pays for the overheads is not the amount invoiced to clients, but rather the amount left after deducting direct costs. The distinction between overheads and costs is made because overheads have to be paid regardless of how much work is undertaken, whereas costs are incurred only when work is done – and can vary depending on the type of assignment.

There is a theory that says it doesn't matter how much profit (invoice value less costs) is made on a job, provided there is profit to some degree. This philosophy is based on the Mr Micawber principle: 'Annual income twenty pounds, annual expenditure nineteen nineteen and six, result happiness. Annual income twenty pounds, annual expenditure twenty pounds nought and six, result misery.' (Charles Dickens, *David Copperfield*). In short, provided that your income exceeds your

Figure 4.5 Digital image manipulation can sometimes be very subtle. If you look carefully you will notice that one of the pictures from the colour contact strip (above) has not only been converted to monochrome but was also extended to provide more background across which the story's headline has been printed (opposite).

TV Kerry . . . real-life drama

Bill stars flee after gas blast kills man

By PAUL THOMPSON

STARS of cop show The Bill fled a TV studio yesterday after a giant explosion shook a gas bottling plant, killing one worker.

Cast and crew were ordered to leave their set amid fears of further blasts at the British Oxygen Company works less than 100 yards away.

Actors were still in police uniform as real cops ushered them clear.

Kerry Peers, who plays detective Susie Croft, said: "We were busy filming and didn't hear anything. Then the fire alarms went off and security ordered us to leave.

Pub

"It was very orderly. We all went to a pub until the all-clear."

The early morning drama happened on an industrial estate in Merton, South West London, where the ITV series is recorded in a warehouse.

A total of 400 people were evacuated, including 200 from The Bill. Filming was delayed 90 minutes.

The explosion, which sparked a full-scale chemical alert, happened as bottles were being filled with highly inflammable methane and carbon dioxide.

The dead worker was Anthony Mulry, 29, who was married and lived in Surrey.

Two other injured, a man and a woman, were sent home after hospital treatment.

SKATE BOYS NAB CROOK

THREE lads on Rollerblades nabbed a burglar as he fled after an attempted break-in.

Nine-year-olds James Coffey, Matthew Langford and Antony Pleasants chased the 19-year-old until police arrived in Keighley, West Yorks.

Yesterday cops praised their bravery. The suspect was charged.

HOW NOW, SOW?

Tania Meyers, 22, of Leigh-on-Sea, Essex, reads love poems to her rare Chinese pigs in a

ON ME AD SON

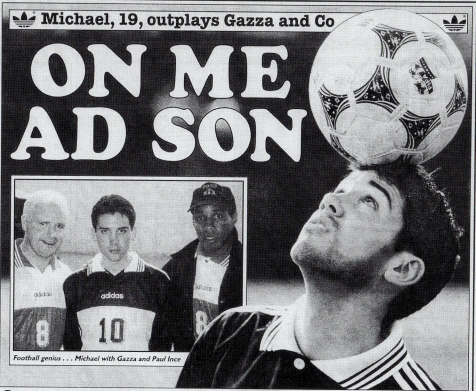

Football genius . . . Michael with Gazza and Paul Ince

Soccer clubs snap up Adidas TV lad

By NICK PARKER

EXCLUSIVE

SOCCER-mad Michael Delaney is set for the big time after appearing as a TV extra — and outplaying the stars.

Michael, 19, so impressed a former World Cup star with his skills in an Adidas ad that he has fixed trials with top German sides including Bayern Munich.

Adidas technical adviser Hansi Muller told the lad: "It would be a crime to waste such genius."

Michael met Paul Gascoigne, Paul Ince, David Beckham and Italian ace Alessandro del Piero doing a new TV campaign for the firm — famous for the three stripes on their sportswear.

He was del Piero's body double during breathtaking action shots.

Worshipped

But Michael ended up **TEACHING** the stars, who were astonished at his ball-juggling brilliance.

Now he has quit his £100-a-week job as a Soccer in the Community coach in a bid to join the elite.

Michael, of Orpington, Kent, said yesterday: "I've lived every schoolboy's dream.

"I was having a kick in my garden, then I was meeting the greatest players in the world.

"Hansi Muller seemed to be very impressed with my skills and asked

Beckham and the other stars. They said they had never seen anyone do some of the things that I can do with a ball.

"Gazza called Ince over to watch me do one trick where I flick the ball on to my feet while sitting down then stand up while keeping it in the air.

"I ended up playing heading tennis with del Piero. It was amazing having a kickabout with players who are worshipped by millions."

He added: "Hansi watched me closely when I played on the pitch and I was stunned when he offered me a chance to train in Germany and have trials for clubs over there.

"I'd played for Cray Wanderers and Corinthians in the Kent League but thought I was never going to be noticed by talent spotters."

The telly advert shows the stars playing clones of themselves — with the side wearing Adidas gear coming out on top.

Muller raved: "I have never seen anyone do the things Michael can do.

"He was del Piero's body double — but I soon realised he had more skill than the man he was playing. He has what it takes to be a great player."

Michael's proud parents Jim, 46, and 45-year-old Gill, hope to visit him soon in Stuttgart.

Gill said: "Michael has been obsessed with football since he was

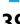
Figure 4.6

Figure 4.7 Whereas the national press is mostly interested in individuals, local papers tend to prefer pictures that have a community context. Michael Delaney, the same young footballer who appeared in *The Sun*'s story, is shown here with the local youth team that he coaches.

costs, then all is well: to get sufficient profit to cover your overheads, all you need to do is get more work.

Plausible though it sounds, this is a very naive approach that risks keeping you always within a knife-edge of going broke. It is far better to do less work and to get a higher profit margin from those jobs. My own philosophy is to do as little as possible for as much as possible – though things rarely work out that way.

Maximum profit is obtained by having your prices high, and your costs low. The danger, however, is that high prices will lose (or discourage) clients, while low costs can mean poor quality: the art lies in avoiding these traps.

The realities of photographic life vary depending on the sphere in which you work and the stage you are at in your career. In general, the biggest fees are paid by clients who have the largest budgets at their disposal. Big spenders include national tabloid newspapers (but only for the right pictures),

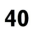

colour supplements, glossy magazines (especially for tasteful exclusive celebrity material) and top-shelf 'adult' magazines. There are other areas too – such as management agencies who represent musicians and film stars – but these are harder to break into. In principle, anybody can extract a four-figure (or larger) sum from a national newspaper *if* he or she has the right pictures. Similarly, if you have a friend who knows somebody who can get you inside a celebrity's house, then the odds are that those photographs will sell. So, too, will a well-executed set of glamour pictures.

On the other hand, a hard-won picture story showing the struggle of slave workers in a dictator-ruled foreign land is unlikely to net the same income – though it will probably take longer to obtain under very much more arduous circumstances. This is the reality of editorial photography.

So if photojournalism in the true sense is not economically viable, and high-income jobs are confined to very small areas, how then do the vast majority of press, editorial and PR photographers earn a living? The answer lies in a sensible volume of sensibly priced jobs. Life is made easier by having regular clients on whom one can depend for a steady flow of work, but it is dangerous to rely too heavily on any single client unless there is a formal contract guarding against sudden changes that might remove that source of income. In the early days, you should work for as wide a variety of clients as possible, and cultivate those with whom you get on well and who pay sensibly (in terms of fees and promptness of settlement). As time goes on, difficult clients – or those who pay poorly – should be dropped and replaced with new ones of a higher calibre.

This is easy to say, but hard to achieve in practice. The first problem is that most of your prospective clients will already have photographers doing work for them. Why should they now use you instead? In fact there are a number of reasons: perhaps there is more work than can comfortably be covered at present, or you might have a style or skill the current photographer lacks, or perhaps you can offer a faster turnaround. Whatever angle you choose, do not simply go for a lower price: if a client just wants to save money, then you too will be out on your ear as soon as somebody cheaper comes along! By the same token, once you have won a regular client, be sure to maintain the highest standards of service so that your own position becomes very difficult to undermine. Chasing new clients is a time-consuming process, so it makes good sense to look after the ones that you have.

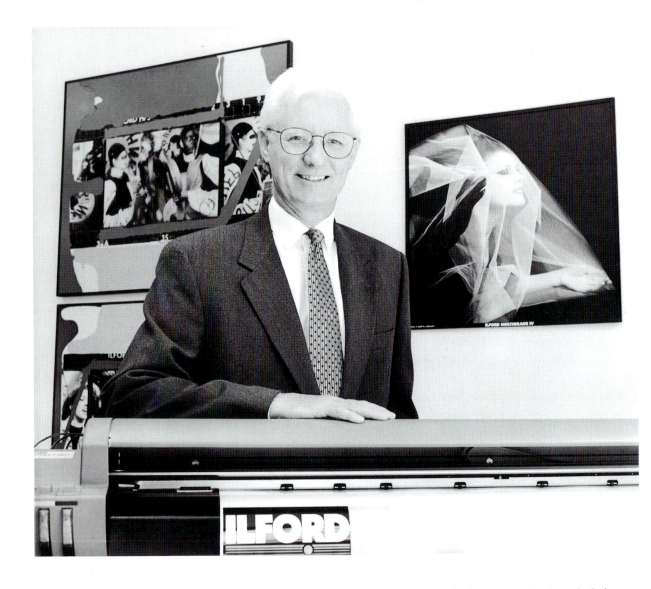

Figure 4.8 A useful trick when doing business portraits is to include something in the picture that helps to identify the company for which the person works.

Getting clients in the first place is an almost impossible task that relies on 90 per cent luck, 10 per cent effort. Unfortunately, your time will be taken up with 100 per cent effort, the bulk of which will bear no fruit. When work comes along, it will be as a result of being in the right place at the right time – but to take advantage of that, you must be where it matters, or know the right people. Alternatively (or additionally), you can subscribe to one of the various newsletters

Figure 4.9 This photograph was created in answer to a specific brief using a set that was built specially for the picture. Filtered lighting was used to give an end-of-the-day look.

that circulate listing the current requirements of publishers and picture libraries. One such newsletter is compiled and distributed by the Bureau of Freelance Photographers.

The biggest mistake that anybody can make is to launch out as a photographer with no clients. You must have some work, no matter how little, before starting in business. That

way, you will know what kind of jobs you are going to have in the early days, and how much income you can expect them to generate. Remember, all this is about predicting your cash flow – and that means the viability of your business. In an ideal world, you could wake up one morning and say: 'From today, I am a professional photographer.' Never again would you need to earn a single penny from non-photographic work. That just doesn't happen. Or if it does, then it is only because there is a wealthy relative in the wings subsidizing the business as it gets off the ground.

Having calculated your monthly overheads, the safest way to proceed is to start the business with reserves equal to one year's outgoings. Broadly speaking, the younger you are, the lower these outgoings will be, but the less opportunity you will have had to accumulate the necessary funds. The alternative, and more likely, approach is to run a parallel career alongside your photography, with the income from that being sufficient to cover all the overheads, but without it taking up so much time that there is no opportunity left for taking pictures.

In my own case, I had a full-time job working in industrial research and development, but was also taking pictures for a local newspaper on a regular basis – mostly covering weekend and evening events. I used my holiday entitlement to approach other potential photographic clients, one of which actually advertised for new photographers in the weekly trade magazine *UK Press Gazette*. When it got to the stage that the two activities could no longer coexist, I left the industrial job knowing that I had two core photographic clients. As it happened, I was invited to take a staff job with the local paper after it was taken over by a new owner, but I declined the offer. I knew, however, that somebody else would accept the position and steeled myself to lose that client. Life has gone on like that almost ever since: one door closes and another one opens.

Pricing

A photographic assignment is worth whatever a client is willing to pay. Forget the idea of working out a price based on time and materials, or a fixed profit margin: the reality is that many clients will offer a job at a certain fee and it will be up to you whether you accept or decline. The decision is not always an easy one. Some people advise that if the fee is less than the costs, then the job should always be rejected, but

there are clients I would work for even if I made a loss in the process. Such assignments would have a value that is expressed in non-financial terms, being high-profile projects or assignments for worthy charities. Similarly, there are jobs I have done that I really didn't want to do, when I demanded a higher than normal fee by way of consolation. (Incidentally, the reasons for not wanting to do a job can vary from being heavily overworked to having reservations about the likelihood of prompt payment.)

But all this is beating about the bush: you have to know your 'normal' rate for typical jobs – even if a particular client can't match that fee. One way of arriving at a figure is by using the typical weekly wage that you would expect to earn in full-time employment, then to set this as your day rate. Half-day and smaller jobs are charged out pro rata. The 'weekly wage for daily work' approach is justified on account of all the other things that need to be done as part of running a business or even completing a particular assignment. Indeed, although it sounds reasonably generous, it can end up very much less so when applied to a two-hour job that might wipe out half a day.

Another useful way of setting prices for press, editorial and PR jobs in particular (as opposed to photographic work in general) is to consult the National Union of Journalists' (NUJ) annual *Freelance Fees Guide*. Whilst union recognition is now very much less common that it has been in the past, the NUJ booklet does remain a respected source of guideline rates for press and PR work.

Having set a day rate, some photographers try to charge extra for things such as travelling time, but clients are rarely happy with this idea. It is normally better to come up with one all-inclusive figure so that everybody knows exactly where they stand.

Although it may not seem like it, there is a philosophy at work here: it is better to charge fully for your core skill (photography) than to add on lots of extras that a client might want to reduce. This principle applies right across all fields, but is often undermined by high street social photographers who offer free sittings and charge steeply for their prints. I have heard members of the public complain that they can get prints done cheaper at a local minilab, overlooking the fact that without the photographer there would be no negatives from which to make the prints!

Charging for taking pictures rather than for the various

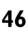

add-ons also guards against loss of income caused by clients looking to cut corners. If you normally supply PR prints at a certain size and price, then one way for a client to reduce your invoice is to switch to smaller prints. Were you to have based a significant proportion of your profit on the prints, then the job would become less valuable for exactly the same amount of work on your part. Clearly, this is not a good position to be in. On the other hand, it can be annoying to be asked for another couple of prints at a later date when you know this will take a certain amount of time and effort for little return. The answer is to have a minimum charge – though you must tell clients this from the beginning so they can order in bulk at the outset if they want to save money.

Pricing strategies are a matter for personal experimentation, and not all clients will be treated equally. The only way you will know whether or not you have got it right is by listening to your clients and monitoring your own income against expenditure. A useful trick is to work on the principle that unless clients say something is too expensive, then the odds are that they would have paid more. When negotiating, sometimes there is room to increase a quote by qualifying it to exclude materials – though this should never increase the fee by more than about 25 per cent at the most. Similarly, if a quote is too high, it can be reduced by restricting something – such as specifying a slower turnaround to take advantage of cheaper processing charges. In practice, you might still pay full price for the processing simply because it can be more convenient to get the job out of the way, but it is better to appear to offer less when accepting a lower fee. Otherwise, you risk looking either unprofessional or desperate for work.

The chances are that during your first year in business you will do little more than cover your costs by the time all incidental expenses, such as stationery and promotional expenditures are taken into account. Your fixed overheads should have been covered by reserves or, in the very last resort, by a bank loan. By the end of your second year, you should aim to be covering all of your outgoings – both costs and overheads. This might sound like the break-even stage, but it isn't. By generating a profit (sufficient excess of income over direct costs to cover your overheads), you will start to attract tax. The net result is that in order to break even, you must have enough excess income to pay your overheads and service your tax bill. Typically, you will need about 10–20 per cent more

HANS MOTORS CLUTCH KITS

FOR POPULAR GERMAN APPLICATIONS

THE QUALITY ALTERNATIVE!

WHY PAY MORE ?

SEE OVERLEAF FOR DETAILS

HANS MOTORS LTD **HM**

OH/291/00/JUN95 PAGE 1

Figure 4.10 A 5 × 4 in monorail camera was used here to provide image perspective control. The picture on the finished leaflet was almost exactly the same size as the original transparency.

PROFESSIONAL PRESS, EDITORIAL AND PR PHOTOGRAPHY

income than is used up in overheads. Only by year three are you likely to be generating a genuine surplus profit – and that assumes that all goes well.

Even so, there is still the matter of money invested in equipment. A good business not only makes a surplus profit, but also achieves a sensible figure in terms of its return on net assets. If you had invested £10,000 in photographic equipment, and made £1,000 of surplus profit at the end of the year after all tax and expenses had been cleared, then you would have got a 10 per cent return on your original investment. Of course, for the first two years you had no return at all, and by now some items will need either replacing or adding to. As a result, your £1,000 will probably be eaten up on reinvestment. If, on the other hand, you had stayed in a nice steady job and had put the same £10,000 into a savings account, then the interest would probably afford a pleasant holiday for nothing every year!

The moral of this tale is that press, editorial and PR photographers tend not be the wealthiest people. Their businesses often hang in a state of balance, not necessarily on a fine thread but frequently from one that is rather thinner than many would like. That situation tends to change as time goes on, but if you want to get rich quickly, don't become an editorial photographer.

Looking the part

Although setting up in business is largely an act of financial commitment, there is also the matter of 'corporate image' to be considered. This is the public view of your business, as defined by your trading name, stationery and business cards. It is also reflected in the way you dress and the kind of car you drive, as well as in the premises from which you work and whether or not you are registered for VAT.

To deal with the last of these first, it is reasonable to predict that few one-person photography businesses will exceed the compulsory VAT registration threshold in their first year. Nevertheless, it can still be useful to register for VAT from the outset if the compulsory registration limit (which tends to increase each year) is likely to be reached within a relatively short space of time. The most obvious advantage of jumping before being pushed is that all the necessary machinery will be put in place from the start: there will be no need to reprint stationery or to surprise clients with the addition of VAT to their invoices at a later date. But useful though this

consistency is, an even better reason for being VAT registered, in my opinion, is the financial discipline that this imposes on your business.

Every three months, VAT registered businesses must fill in a return that details expenditure and income, with the balance between VAT invoiced and VAT spent being payable to Her Majesty's Customs and Excise Office. This means that rather than waiting until the end of the year to see how your business is going, there will be an opportunity to review progress every quarter. And if you happen to have spent more VAT that you earned – as could well be the case for your first one or two returns, – then the VAT office will send you a cheque for the difference. Be warned, however, that if you subsequently decide you no longer want or need to be VAT registered, then the VAT office may require a similar settlement cheque from you.

As far as most areas of editorial photography are concerned, it makes no difference whether you are VAT registered or not because most clients will be registered themselves, and will simply offset the VAT you charge in their own returns. For other types of clients, and always when dealing with the general public, being VAT registered can be a disadvantage because it increases your prices (or reduces your profit margin) in comparison with somebody who does not have to charge VAT. This said, somebody who is not VAT registered cannot be as financially successful as somebody who exceeds the VAT threshold: if you register for VAT voluntarily, people may well assume that your turnover is above the compulsory VAT level even if it isn't.

Cars, clothes and premises are subject to individual tastes, pockets and the types of people you want to impress. Older cars can be made to look newer by fitting a personalized number plate, while addresses can be made to sound more impressive by strategic renaming. I know of one photographer who calls his flat Nightingale Studio: somebody who didn't know otherwise would assume that this was his commercial premises and would certainly not guess that he worked from home. Significantly, there is now very much less stigma associated with working from home than there once was, especially if home is simply the base where you rest between going out of different assignments. If, however, you undertake commissions at home – having turned one room into a small studio, for example – then beware that this can contravene the conditions of domestic mortgages, and can also risk the wrath

Figure 4.11 A5 photographer's card printed with the same picture logo that also appears on matching small business cards and letterheads.

Figure 4.12 Additional card printed for distribution through the photographer's agent. A totally different style is portrayed in the alternative design.

JON TARRANT

Represented by

Edward Davies
· · · · · · · · ·
Photographer's Agent

JON TARRANT

Represented by

Edward Davies

Photographer's Agent

19°90

JON TARRANT - PHOTOGRAPHER

KODAK PRESS AWARDS

JANUARY						
S	M	Tu	W	Th	F	S
	1	2	3	4	5	6
7	8	9	10	11	12	13
14	15	16	17	18	19	20
21	22	23	24	25	26	27
28	29	30	31			

FEBRUARY						
S	M	Tu	W	Th	F	S
				1	2	3
4	5	6	7	8	9	10
11	12	13	14	15	16	17
18	19	20	21	22	23	24
25	26	27	28			

MARCH						
S	M	Tu	W	Th	F	S
				1	2	3
4	5	6	7	8	9	10
11	12	13	14	15	16	17
18	19	20	21	22	23	24
25	26	27	28	29	30	31

APRIL						
S	M	Tu	W	Th	F	S
1	2	3	4	5	6	7
8	9	10	11	12	13	14
15	16	17	18	19	20	21
22	23	24	25	26	27	28
29	30					

JON TARRANT

MATT GOSS

RICHARD BRANSON

MAY						
S	M	Tu	W	Th	F	S
		1	2	3	4	5
6	7	8	9	10	11	12
13	14	15	16	17	18	19
20	21	22	23	24	25	26
27	28	29	30	31		

JUNE						
S	M	Tu	W	Th	F	S
					1	2
3	4	5	6	7	8	9
10	11	12	13	14	15	16
17	18	19	20	21	22	23
24	25	26	27	28	29	30

JULY						
S	M	Tu	W	Th	F	S
1	2	3	4	5	6	7
8	9	10	11	12	13	14
15	16	17	18	19	20	21
22	23	24	25	26	27	28
29	30	31				

AUGUST						
S	M	Tu	W	Th	F	S
			1	2	3	4
5	6	7	8	9	10	11
12	13	14	15	16	17	18
19	20	21	22	23	24	25
26	27	28	29	30	31	

JON TARRANT

BP NETBALL TOURNAMENT

SEPTEMBER						
S	M	Tu	W	Th	F	S
30						1
2	3	4	5	6	7	8
9	10	11	12	13	14	15
16	17	18	19	20	21	22
23	24	25	26	27	28	29

OCTOBER						
S	M	Tu	W	Th	F	S
	1	2	3	4	5	6
7	8	9	10	11	12	13
14	15	16	17	18	19	20
21	22	23	24	25	26	27
28	29	30	31			

NOVEMBER						
S	M	Tu	W	Th	F	S
				1	2	3
4	5	6	7	8	9	10
11	12	13	14	15	16	17
18	19	20	21	22	23	24
25	26	27	28	29	30	

DECEMBER						
S	M	Tu	W	Th	F	S
30	31					1
2	3	4	5	6	7	8
9	10	11	12	13	14	15
16	17	18	19	20	21	22
23	24	25	26	27	28	29

of local authorities if the building is classified for residential use only. In addition, working from home can incur a tax liability if you subsequently profit from the sale of the property, so do tread carefully in this area.

By and large, cars and addresses attract very little attention unless they are truly extreme. Stationery, trading names and business cards, however, are a very different matter because these are the things people see whenever you communicate with them. It is unlikely that you will hit upon the perfect image first time, so avoid spending too much on design and printing in the early stages. As far as trading names are concerned, there are clear advantages to using your own name in terms of identification and avoidance of business name conflicts. The disadvantage is that expansion can be difficult and there is no independent business identity to sell as an asset if you ever so desired. In the editorial field, the balance tends to fall in favour of immediate identification, though in other areas of photography things can be different.

Letterheads and business cards can be obtained at remarkably low cost if you shop around. Nevertheless, and despite the advice to spend as little as possible at first, always remember that your stationery is your shop window: it defines the way people think of you when you are not there in person. Never economize to the point where it becomes detrimental to your image.

Figure 4.13 Promotional items are a useful way of keeping you in clients' minds.

5 OTHER CONSIDERATIONS

Running a photographic business is about more than just taking pictures. In particular, there are four other major areas that need to be addressed if things are to run smoothly. The first two are communications and processing, the before and after stages that sandwich picture-taking itself. The third is lighting, about which many editorial photographers know surprisingly little. The last is the combined subject of insurance and security. All four topics have implications for buying equipment and also in terms of working methods.

Good communications are vital for any business, and are especially so for freelance photographers who may need to be contacted at a moment's notice by any of a number of different clients. A mobile telephone is therefore virtually essential. Unfortunately, mobile telephones have something of a reputation for being money pits – which the early ones definitely were. Modern air-time contracts are much more user-friendly: even so, the secret to keeping mobile telephone costs down is never to make calls out, but only to receive them! Telephone technology and network services are such that there is little point going into great detail here other than to say that even the cheapest mobile will be absolutely fine for the essential task required. More expensive models have more features, including data transmission capabilities that allow digital or digitized pictures to be transmitted direct to clients from remote locations. This sounds like a useful idea – and indeed it is, though not necessarily from day one.

More discrete than a mobile telephone, but not as immediate, is a pager. Not many photographers rely on pagers alone, but a number do use them in conjunction with a mobile telephone. In the process, it is easy to acquire a whole host of different contact numbers, especially if you give out your home and office/studio land-line telephone numbers too. To overcome this problem, it can be useful to distribute just one

FEBRUARY 1995 No. 321

Viva Lancia!

 The Magazine of the Lancia Motor Club

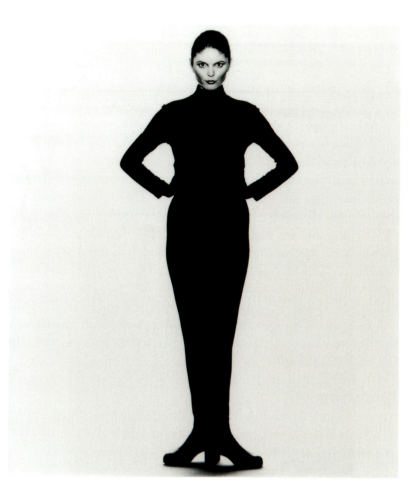

**Figure 5.2 Model testing is a very
good way of trying out new ideas –
in this case, a silhouette effect that
is broken only by a tightly focused
spotlight on the model's face.**

number and to redirect calls from that number to wherever
you happen to be. Obviously, it takes a bit more effort to
remember to do the redirection, but if this makes a client's life
easier then it is well worth considering. Alternatively, all land-
line telephones should have answering machines that give
your mobile number, and the mobile should itself have a
message recording facility in case callers cannot get through to
you in person.

On the subject of communications, care should be taken
regarding on-line electronic mail (e-mail) systems. People
who send messages this way tend to assume that the text has

**Figure 5.1 This picture was created using a double exposure technique
on a single black and white negative. The car was a 1/18th scale model
that was lit using a small overhead softbox: the background was provided
by a projected transparency that was exposed separately.**

been received as soon as it is sent, and often expect a reply almost by return. Unless you have a daily routine that involves picking up electronic messages, it is better not to invite people to communicate with you this way. Almost always, the fastest way to get hold of somebody is via a mobile telephone, not by e-mail.

Other items of office equipment are more of a luxury than a necessity. The most likely items for early purchase are a fax machine and a photocopier: fortunately, many models fulfil both functions at only modest cost. There is no need to increase overheads by having the fax machine on its own telephone line unless you expect it to be used very heavily. However, if the fax machine does share a normal telephone line, then check that it is designed to do so. Some of the better machines feature a facility that activates the fax from any extension telephone simply by entering a number code. This can be very useful for times when you accept a call away from the fax machine (in the darkroom, for example) only to hear fax tones on the other end of the line.

Processing

At some stage or another, every editorial photographer is put in a situation where it would be very useful indeed to be able to process film without having to rely on a laboratory or a press darkroom. Luckily, negative film processing, in both black and white and in colour, is remarkably easy to do. All you need is a daylight tank, the appropriate chemistry and a supply of clean water. At a push, film can be loaded into the tank deep under the covers of a bed, or shut away inside a cupboard with rolled towels or draped blankets blocking the gaps through which light could seep in. More convenient still is a daylight changing bag, which will also prove useful one day for extracting film that has got damaged or jammed inside a camera. A daylight bag can be folded flat and should be tucked away inside your camera case for that unforeseen occasion when it will separate success from failure on location.

The preceding comments are aimed mainly at press photographers, and suggest a very much more rough and-ready approach than is appropriate for most types of non-news editorial and PR photography. In general, the decision whether or not to undertake processing in-house as a matter of routine will depend on how your business is organized. If you need a speedy turnaround to satisfy your clients then you may have no choice, but it is more common for in-house and laboratory

processing to be equally viable: how then do you decide between the two?

One theory says that in-house processing is cheaper than using a commercial service. This is only partly true. Another theory says that editorial photographers should keep as much control over their pictures as possible, and should therefore print all their own images. This is definitely *not* true.

In-house processing is often cheaper as far as black and white films and prints are concerned, but is also rather time-consuming. Photographers who are fully booked with assignments simply won't have enough time left over to spend hours – or maybe days – producing final prints. Colour printing can be cheaper when done in-house, but the cost savings can be small compared to using a professional laboratory that services this market in volume. Colour transparency processing should only be undertaken in-house if you have access to sophisticated (and therefore relatively expensive) processing

Figure 5.3 Jonco's Filmeze is a good example of an automated film processing machine that is well suited to in-house use. It is very unlikely, however, that films processed in small machines will match exactly those processed at commercial photographic laboratories, so it is best to choose one route or the other and to stick with it.

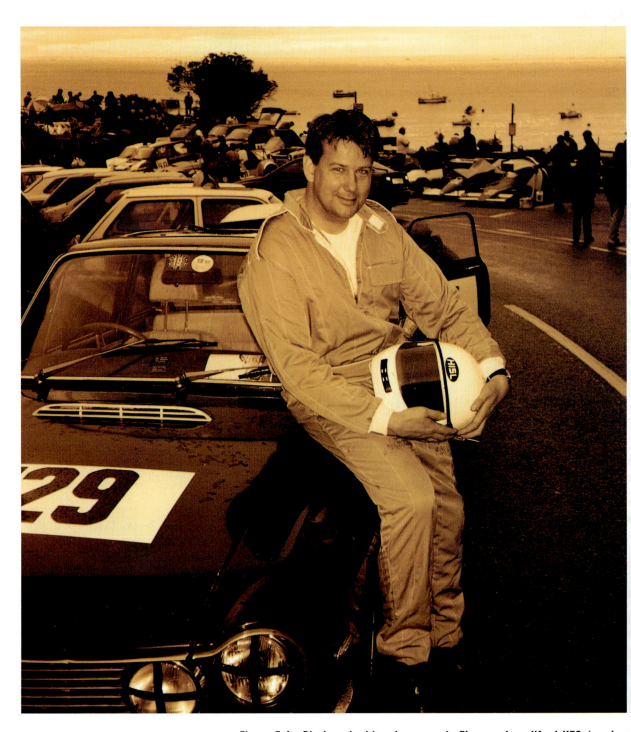

Figure 5.4 Black and white chromogenic films, such as Ilford XP2 (used here) and Kodak T400-CN, can be processed in a colour minilab machine. Their prints tend to have a slight colour cast that is sometimes exaggerated to give a distinctive sepia effect (as above). When neutral black and white prints are needed, chromogenic films can also be printed onto conventional monochrome papers with great success (see opposite). Photograph by Lin Tarrant.

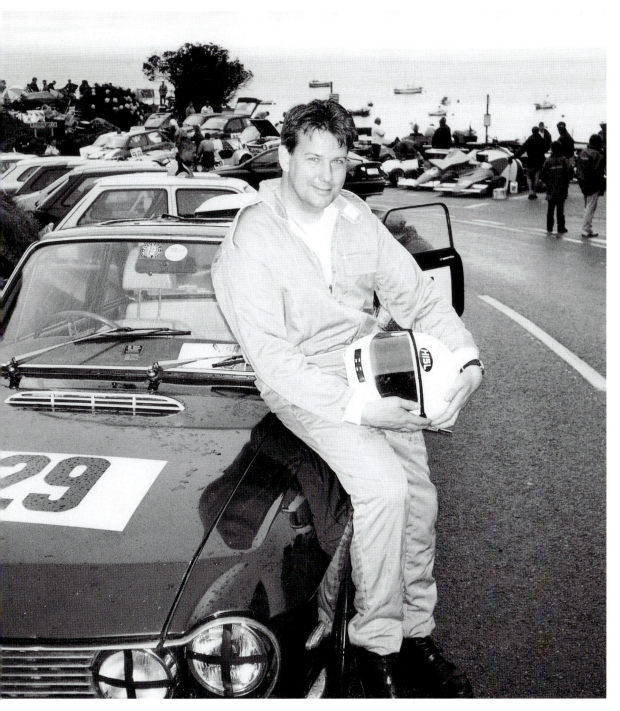

Figure 5.5

equipment that ensures consistent quality. The problem with colour transparencies is that if the processing goes wrong, the job is ruined. All your efforts behind the camera will have been wasted for the sake of saving perhaps £1 per roll. And if you decide to invest in sophisticated processing equipment to safeguard colour transparency quality as far as possible, then this will be yet another expense that must be funded up front and amortized over the following years. Unless your use of colour transparency film is high, it is unlikely that in-house processing will offer any real benefit – and if it is high, then you probably won't have the time to do all that processing anyway!

Then there is the matter of control. Once again, all the time and expense arguments apply, but now there is also the significant matter of expertise. Top printers, both black and white and colour, are people who devote their lives to this one area of activity. What makes you think you can do a better job than they can? Probably, you can't. When photographers give a printer a negative and are disappointed by what they receive back, it is almost always because the picture they wanted was never on the film in the first place. Bad photographers blame their printers, and retreat to their own darkrooms to spend hours dodging and burning to make up for their failures behind the camera. That just doesn't make economic sense.

But there is also another side to darkroom work, which is the sheer thrill and enjoyment of printing pictures just for the pleasure of it. This is printing as a hobby, not as a commercial venture. There is nothing wrong with it – in fact, it can make you a better photographer if you attend to how your images turn out on film in comparison with how you hoped they would look.

As far as darkroom equipment goes, you can start with very basic facilities and move up as your experience grows. It is easy to read magazine reviews about the latest items of darkroom kit and to assume that all the top people use the most modern equipment. They don't. By pacing your acquisitions you will be able to take advantage of special bargains

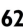

Figure 5.6 The final result shown here is due to the combined effect of the posing, props, lighting and printing. It is easy to overlook the importance of the latter: there can be no doubt that top quality printing (provided here by Melvin Davies of Master Mono) can significantly enhance any photograph.

and will get very much better value for money than if you had rushed out and bought everything at once.

It may be interesting to reveal that I didn't have my own darkroom facilities at all for the first few years, but relied instead on being able to use somebody else's. Even when I was working for a local paper in south London, the enlarger and lens that I had were incapable of producing decent prints bigger than about 8 × 10 in, so I never did anything larger than 8 × 6 in! Admittedly, I do look back on some of those prints with embarrassment, and I would shudder to produce the same quality now, but a lot of paper has passed under several different enlargers since then.

Lighting

Without light, there can be no photography. Without careful lighting, it is impossible, except by chance, to get good pictures. Lighting is not about the quantity of the light, but its quality. That doesn't necessarily mean you cannot make use of the natural light that is all around, but it does mean that available light must be used consciously, not just taken for granted. There are, of course, times when a photographer has more important things to worry about than the quality of the light – when getting a picture of any sort is more important than getting one that is artistically superior. And in any case, newsprint is a great leveller that reduces most images to one mediocre standard simply because of the mechanics of publishing. When people see a picture in a newspaper, magazine or book and comment how wonderful it is, they should reflect on how much better the original will have been – which is one reason why editorial photographers often feel the need to exhibit their work at some stage in their careers.

For that vast majority of occasions when there is the opportunity to manipulate the lighting, it is important to be aware of the effect that light can have on a picture. At the most basic level, such opportunities arise whenever anybody says: 'Where do you want me to stand?' If the picture is a simple portrait, then often this question lays the way to taking the person outside if he or she is indoors, or moving into a shaded doorway if you are already outside and there is bright direct sunlight. As far as people pictures are concerned, soft light is invariably more flattering than harsh light.

If you are sent somewhere to photograph a location or an item of heavy equipment, for example, then you would be very foolhardy indeed to assume that the prevailing light will be

perfect for photography: it might be too dim, or fail to illuminate the most important area (such as the name plate on industrial plant), or be of an unknown spectral quality. The last of these is a particularly common problem that is, according to some authors, best tackled using a colour temperature meter. While this is a perfectly good approach in theory – provided that you have the appropriate correction filter(s) – a far easier solution in many cases is simply to use your own lights of known spectral quality for the main subject, and to let the ambient light illuminate the background. The fact that the subject is neutral and the background is slightly coloured will probably enhance the picture's impact.

The next problem that commonly arises relates to the practicalities of using photographic lights on location. Will there be power points with the right type of sockets, and how long will the extension cables have to be? Such worries can be avoided by using a battery-powered flash system. There are a number of such units on the market, the best known of which are made by Lumedyne, Norman and Hensel. These systems differ from conventional flashguns in that they have separate batteries that can power two flash heads or more (if the appropriate accessories are used). Power adjustment is manual, with the maximum settings typically matching those of mid-range mains powered flash units. Dish reflectors can be removed and other devices can be fitted if so required. The Lumedyne head can also be slotted inside an empty Elinchrom shell, so allowing the use of all Elinchrom reflectors, softboxes, honeycombs, etc. Overall, compared to a modest mains powered monobloc, battery units require few sacrifices in terms of brightness yet offer very much more flexibility in terms of where and how they can be used.

To fire a battery-powered flash system, it makes more sense to use a wireless trigger than to employ a long connector cable. Such triggers operate using either infrared light or a radio signal. Neither system is perfect. Infrared triggers can be blocked by bright ambient light levels and can sometimes be set off by fluorescent tubes or other flickering lights. Radio slaves can be rendered ineffective by sources of radio interference, such as some types of heavy industrial machinery. Only very rarely, however, will a particular situation be unsuitable for both infrared and radio triggers, so owning both should cover most eventualities. Nevertheless, always carry plenty of long connector cables just in case all else fails.

**Figure 5.7 Systems Radio Slave
flash trigger – the ideal way to
avoid trailing cables.**

Specific lighting techniques are covered elsewhere, but before leaving the subject of lighting it is important to mention that there are some types of assignments for which flash is not appropriate because its use is either banned or frowned upon. As well as some sports situations and certain events that have television coverage (where flash is considered to be something that disturbs the viewer's enjoyment), places like telephone switching rooms operate a total ban on all equipment that emits an electromagnetic pulse of any sort. If in doubt, always ask before firing even the smallest flashgun in any unfamiliar environment!

Insurance and security

The risk of causing damage to a third party's property cannot always be foreseen, yet could bring serious financial repercussions. To guard against a potentially ruinous situation, you should have public liability insurance that covers you against injury to others and their property. In addition, if you have employees then you must take out employer's liability insurance which provides similar benefits for them.

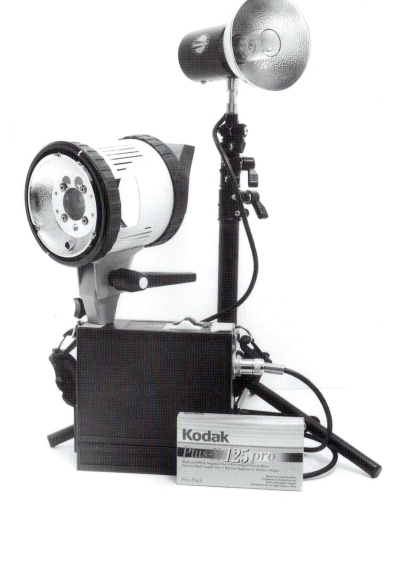

Figure 5.8 Lumedyne makes a compact, powerful and remarkably versatile battery-powered flash lighting outfit that can prove very useful when working on location. Despite the scale of its components, the Lumedyne system is capable of producing as much light as a mid-range studio monobloc.

Liability insurance is important because it protects against the unknown and does so with a high level of cover for a relatively low annual premium. More expensive to obtain, and lower in protected value, is equipment insurance. The reason why this is comparatively expensive is because it is more likely that you will lose, break or have stolen a camera than that you will inadvertently cause the death of an innocent bystander during the normal course of your work.

The statistics that govern insurance are the same as those that form the foundations of gambling. They hinge on the concept of expectation: how likely is it that a loss will occur,

and how much could that loss cost to rectify? If, on average, one camera in a thousand is the subject of an insurance claim, and that average camera costs £2,000 to replace, then the expected loss per insured camera is £2. If owners each paid £2 into a kitty, then there would be enough to cover the average loss.

Unfortunately, two things complicate this simple model. One is that although the average rate of claiming might be one in a thousand, that doesn't preclude two or more people from making claims (though it does become increasingly unlikely that a higher number of genuine losses will occur within any one group). The second complication arises because insurance companies are in business to make money. Therefore, in order to arrive at an insurance premium, the expected average loss figure will be multiplied by a factor that provides a safety margin and also leaves plenty of room for profit.

Insurance companies base their premiums on a percentage of the value of the equipment covered. Normally, the value specified is the cost of buying new replacement items. Unfortunately, difficulties sometimes arise in respect of an item that has been discontinued or improved to such a degree that the nominated replacement is not on a par with the insured original. If the company feels that you have underinsured yourself, then it will refuse to settle your claim in full. Worse still, if you overinsure, then all your premiums will have been higher than the amount of cover for which you actually qualify. In this case, you will simply have wasted your money.

The percentage on which premiums are based varies from one company to another and with the level of expected risk. Studio-only insurance is the cheapest, rising to all risks cover worldwide (with specific exclusions relating to war and civil disturbances). Normally, insurance is for particular items, but it can also be for a fixed maximum amount, which can be very useful when only one of several different kits is taken out on assignment at any time. As always, shop around for the best deal that is most appropriate to your own needs.

Unlike liability insurance, which is virtually essential for a quiet night's sleep (and is required by law in respect of full-time employees), equipment insurance is optional. Provided

Figure 5.9 A photographic safe is the ideal place in which to store valuable, but easily removed items of equipment.

that you never suffer a total loss, you will probably end up better off having put the money that you would have spent on insurance premiums into a savings account instead. In addition, installing an alarm or a robust safe can help to prevent losses in the first place. Effective alarms and safes can each be obtained for about the same outlay as one year's professional equipment insurance (and will remain effective for very much longer than just twelve months).

One of the most important advantages of the combined alarm and safe approach over insurance alone is that it reduces the likelihood of your business being disrupted while the insurance company takes its time assessing your claim. Some insurance companies now insist on alarms (though not usually safes) as a condition of cover, doing so to reduce the risk to themselves. For those who suspect otherwise, this is proof that alarms definitely are effective – if only to encourage opportunist thieves to leave your premises as quickly as possible. And it is in this context that a safe becomes particularly important.

Compared to the bank vault type, equipment safes are more akin to heavy duty, reinforced storage cupboards, with fully protected hinges and multibolt locks. The amount of equipment that can be stored inside depends on the safe's size and the way in which it is packed (whether items are stored separately on shelves or packed into carrying bags). Nevertheless, even a modest safe will probably accommodate three complete camera kits and a small lighting outfit, and should defeat all but the most determined attacker.

For the same reason that they favour alarms, insurance companies would probably like all businesses to store their small valuables inside a safe. However, the companies know that if they insist on too much additional expenditure, businesses will simply give up on insurance all together.

This somewhat cynical assessment may well be taken as an indicator that I am not a huge fan of insurance as a means of guarding against equipment losses due to theft. Prevention, I would suggest, is better than cure – especially since claiming on insurance is rarely quick, and for as long as the claim process takes, you and your business will be in a state of turmoil.

The other side of insurance is the possibility of accidental damage – which is quite a different matter. This is something that is unavoidable, and is the reason why, if you opt for preventative measures rather than annual premiums, you must put money aside to cover unfortunate eventualities.

Deciding not to take out insurance is not a way of saving money, but rather is a philosophy that prefers to reduce the risk of having to make a claim, and at the same time provides an emergency fund that is readily available without having to convince an insurance company that the item you want to buy is justified in respect of the loss suffered.

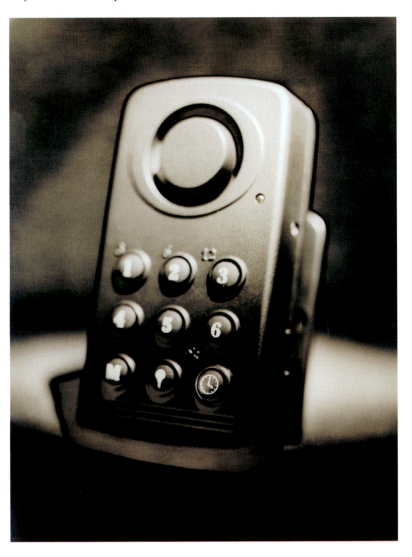

Figure 5.10 Portable alarm of a type that can be used to secure everything from equipment cases to hotel doors.

6 UP AND RUNNING

You've got your overheads as low as possible, you've bought your basic items of equipment and you've even got a couple of clients who will give you work. Only now it is time to start earning a living as a full-time photographer.

Initially, you should have just two priorities; to keep your start-up clients completely happy and to find additional clients as quickly as possible. It is difficult to predict the number of regular clients needed to make a business secure, but usually it is a case of the more the merrier. In particular, be very wary of being overdependent on any one client. Ideally, no single client's commissions should be critical to your own survival. All of your clients should be made to feel equally important: indeed, each ought to feel that even if he or she isn't the only person for whom you work, there is certainly nobody else who is held in higher esteem. Given the fact that this cannot be an accurate reflection of the true situation in all cases, there may seem to be an element of hypocrisy at work here. Perhaps there is, and if you prefer to be brutally honest with people then why not go the whole hog and cancel one job at the twelfth hour if another more lucrative assignment comes along (as one photographer I know has done in the past), but don't expect to keep your clients for very long.

The golden rule of accepting work is that it must always be completed. Not only that, but it must be completed on time, to budget and to the required standard. I wish I could think of half a dozen different ways to rephrase those rules, because they are the linchpin that secures the long-term survival of any business.

Never abuse a client. Never cancel a job. Never fail to warn a client if you encounter difficulties that will affect delivery or content of the pictures. And don't invoice for more than was originally agreed unless you have a very good reason to do so and have previously discussed this with the client.

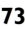

In addition, it is rude to let an invoice arrive before the pictures to which it relates so, to be safe, leave a couple of days between sending the two. This also gives the client an opportunity to call and query anything before you start asking for money. An unhappy client will view an invoice as something that only adds insult to injury – and definitely won't have any intention of paying until his or her unhappiness has been resolved.

Terms of business

Everybody has terms on which they do business, but not everybody has a formal schedule that sets out what these terms are. If you want to be able to enforce your terms in a court of law, then they must be made known to the client. The easiest way to do this is to print a summary on the reverse side of job acceptances, delivery notes and invoices. It is a good principle to ensure that whenever work is undertaken, it is done on your own terms rather than on the client's.

Although terms of business become very important when problems arise, they are even more useful in defining the way in which you expect things to operate on a daily basis. Three particular areas should be addressed: liability, payment and copyright. These aspects can be covered using clauses based on, but not necessarily limited to, the following:

1 The photographer accepts no liability for non-supply of pictures for whatever reason. It is the client's responsibility to ensure that all the necessary clearances have been obtained to allow the pictures to be taken without hindrance or infringement of trademarks or copyrights.
2 Any queries relating to the pictures or to the invoice must be raised immediately upon receipt. Pictures cannot be rejected for reasons of style or composition. Invoices must be paid within the specified period. Overdue invoices will be subject to interest at a rate that will be notified on request or at least seven days prior to becoming effective on a specific invoice.

Figure 6.1 Cast picture for The Blue Angel, lit using tungsten lights for a shadowy, theatrical effect. The photograph was taken not on stage but in a community hall that was being used for rehearsals.

Figure 6.2 Sharpness and blur convey the air of excitement in a London nightclub. The effect was created by combining a slow shutter speed with electronic flash.

3 The photographer retains full copyright in all images. The client is licensed to use the pictures only for the purpose(s) specified. No licence becomes effective until the invoice is paid in full. The licence is granted to the named client only, and is non-transferrable.

Of these three, copyright is probably the most important issue. In particular, there is a crucial distinction to be made between giving the client a licence versus passing over the entire copyright in an image. The difference is not always easy to grasp but has usefully been compared to the situation that applies when renting somewhere to live. In this situation, you have the right to use the building but you do not actually own it. As such, there are particular limitations placed on what you can and cannot do. Renting is like licensing. If, on the other hand, you buy the building outright, then you can do whatever you want and nobody has the power to stop you. Buying is like owning the copyright.

A full explanation of the finer points of copyright is given in a very useful booklet entitled *The ABC of UK Photographic Copyright*, which is available from the British Photographers Liaison Committee (see Appendix for details).

The exact terms of copyright legislation are currently subject to proposed harmonization throughout Europe. The one thing that will not change, however, is the fact that the copyright holder has ultimate control over what can and cannot be done with any photograph. Yet despite this, any legal difficulties that arise over the publication of a picture are likely to be the concern of the publisher, not the photographer. To a degree, photographers are currently in a position whereby they enjoy the best of all worlds – provided, that is, they retain the copyright of their pictures.

Unsurprisingly, clients often seek to acquire the copyright of a picture because there are then no limits to the ways in which it can be used. This would be a reasonable argument (with a few qualifications) were it not for the fact that the value of a picture is defined when it is commissioned. If somebody asks you to take a fairly routine portrait of a celebrity for a magazine or newspaper, then you are unlikely to be paid very much for the job. If, by some quirk of fate, that person is subsequently involved in a bigger event, either good or bad, then the value of your pictures can increase enormously. But if the client holds the copyright, you will benefit by nothing more than your original fee, while your client may be able to pocket considerable additional sums. Unlikely though this scenario might sound, a very similar situation did occur some years ago, much to the consternation of the photographer concerned.

The other face of this problem is even more insidious. It involves a client commissioning a job at a particular rate, saying that the pictures are for a certain application but knowing full well that they will be more widely employed. The inevitability is that the fee will be based on the least valuable application, and if you assign copyright you will have no comeback when it becomes apparent that there has been greater usage than was originally anticipated.

By the same token, only if a client is specific about the uses to which pictures will be put can an accurate job quote be given. The significance of this is that 'accurate' here really means 'minimum'. No client wants to pay more than is absolutely necessary for a job, and no photographer wants to price himself or herself out of the market. So if a picture is just

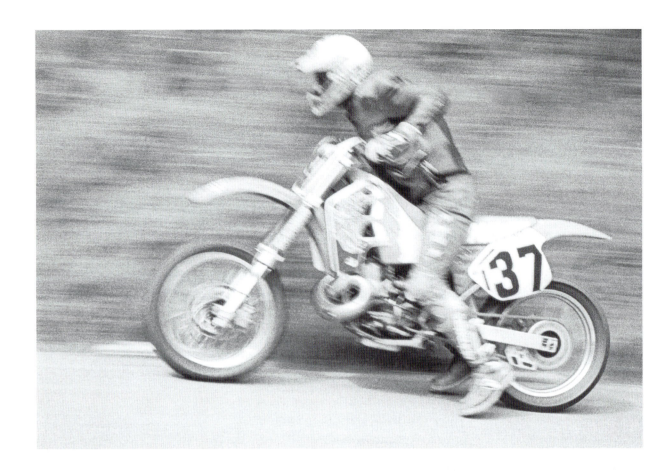

Figure 6.3 Creative use of blur often seems like a nice idea, but press pictures need to be identifiable if they are to be of value. Fortunately, this motorcyclist's racing number is clearly legible.

for the inside of a local paper, then the fee will be lower than if it were for the front page of a mass-market consumer magazine, which would in turn probably be less than the fee paid for a book cover. It is fair to say that the more you are paid for a job, the less likely it is that you will pester the client for further payments on account of additional uses. Inevitably, therefore, the clients you will end up pestering most are the mean or dishonest ones – and who wants those clients anyway?

In summary, the amount of money you can expect from a job is related *not* to the work involved but to the application for which the pictures will be used – and therefore to the available budget. This is why the traditional 'time and materials' approach is so inappropriate when costing photographic assignments. Your fee will also be related to the rights that the client wants. To return to the accommodation analogy, it is significantly cheaper to rent than to buy – at least as far as capital outlay is concerned. So it should be with photographs: if a client really does insist on taking over the

copyright, then he or she will have to pay a commensurate fee.

Photojournalist Roger Bamber tells the tale of visiting an aircraft graveyard in Arizona to shoot an editorial story, and there meeting his friend, the late Chris Joyce, who was shooting very similar pictures for an advertising campaign. 'He was doing it for Standard Chartered and was paid in thousands. I was doing it for the papers and got very much less.' History does not relate whether Joyce had to give up his copyright (something that would have been taken into account as part of the higher fee), but Bamber definitely did not. If you do assign copyright, you wave your pictures goodbye: you may not even be able to do anything with the outtakes from the job.

Clients who absolutely insist that they must have all rights, and are prepared to pay for this privilege, should be granted a non-exclusive 'all-rights' licence. This allows the client to do anything he or she desires with the images, but does not transfer copyright. Most important of all, it means you can still use the pictures yourself – though clients may insist on a period within which you agree not to supply the pictures to any third party. This arrangement is a good all-round compromise if no other agreement can be reached.

Cash flow

No matter how much a job is worth, the money means nothing until it is in your bank account. Ideally, that account should be a business account that runs totally separate to any personal accounts you might have. Although a business account (after an introductory free period) costs money to run – even when it has a healthy positive balance – having one helps to introduce discipline in terms of allowing sums paid from invoices to be viewed as something quite separate from money that can be spent on non-business items. As has been mentioned previously, invoiced income must cover the incurred expenses, general costs and tax before anything is spent on other things.

The best way to introduce the necessary discipline is by setting a fixed amount that your business will pay you each month, then transferring this sum to your personal account to do such things as paying the rent and buying food. If, after covering all your costs, there is a net surplus in your business account, then you can pay yourself a bonus at the end of the year.

That is the theory. In practice, you will receive invoiced monies only some considerable time after the job has been completed. A three-week delay from buying film to getting paid should be viewed as the absolute minimum to be expected. More often, the delay will be six to eight weeks. With slow-paying clients it could well run to three months. Aside from the problem of paying living expenses in the mean time (something that should have been allowed for before starting the business – see Chapter 4), there is also the matter of direct expenses such as film and processing.

Running accounts at suppliers and processing laboratories will help to ease such payments. Even if you don't need the convenience of interest free credit (which is what an account amounts to), there are normally other financial advantages, such as being able to hire equipment without having to leave a deposit, that make accounts worth while. In addition, a well-managed account, like a well-managed overdraft, is a sign of financial health, and will often prove useful when the time comes to seek loans or other assistance to expand your business.

For much the same reason, however, accounts can only be opened subject to satisfactory business references – which are hard to obtain during your first few months of trading. It is useful to have cultivated the acquaintance of a retailer and a laboratory prior to setting up in business, because these people will already know you and should therefore be more receptive to the idea of giving you credit facilities. Failing that, your accountant or bank will probably agree to write a reference on your behalf, but will almost certainly insist on charging for this service.

Once an account is in place, the art is to ensure that you always have the funds necessary to settle it when the due time arrives. There will be occasions when this is still before you have been paid yourself, but at least you will have thirty or sixty days in which to gather the money needed. In the rare event of a client paying you earlier than expected, settle your account early too. Not only is this polite, but also it avoids the danger of you spending the money in the mean time. It is worth noting that processing laboratories are especially good at talking to each other when it comes to bad debts on accounts, so don't think you can run up a bill at one laboratory, then just move on to another. Sooner or later, you will be taken to court and could be declared bankrupt!

Solving problems

It may sound very negative to have mentioned bankruptcy, and now to be discussing other types of problems that can arise, but it will be your ability to overcome such hurdles that will see you through in the long term.

Despite clauses in your terms of business to say that you accept no liability for failure to supply pictures, and that the client has no right to reject (refuse to pay for) pictures on the grounds of style or composition, when such situations do arise – as inevitably they will – amicable solutions will have to be found.

If you arrive at a job and are unable to take any pictures at all, then you must notify your client immediately. In certain circumstances you will be unable to take pictures officially, and may have to resort to surreptitious means: your ability to succeed will be a direct measure of how well you cope with the assignment.

Jobs like these are often undertaken for certain types of newspaper stories. They are not to everyone's liking, but they do have to be covered by those in this field. When doing these sorts of assignments, never work alone. It may sound over the top, but things can get very nasty indeed. A reporter and I once had to speed away from a person who didn't want to be interviewed or photographed: as we did so, the individual threw something at our taxi, breaking the rear window. We drove straight to the nearest police station!

More commonly, you might arrive at a factory and be refused entry because nobody has cleared your visit. Using either a mobile telephone or a nearby public call box, you need to ring your on-site contact. If that fails, you must ring your client to explain the situation. Mention also that if the whole thing falls through you will have to issue a cancellation invoice for the time you have wasted – though only very rarely does it ever come to this.

The second type of problem is the person you were sent to photograph being unavailable, or the machine concerned having broken down, or the building being covered in scaffolding. The first of these is handled in the same way as being refused access: the other two require you to take a picture of some sort. To cover yourself, take two pictures; one should show the extent of the problem at its worst while the other should be your best attempt to work around the problem. It might be that the latter will be acceptable to the client, but if it isn't, the former will be all you need to explain the difficul-

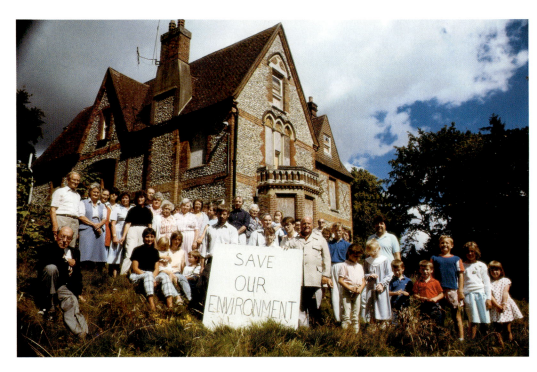

Figure 6.4 The story behind these two pictures was the impending demolition of a local historic house. As well as the conventional protest picture (above), I also tried something a little more unusual (below): predictably, it was the more normal picture that got published.

Figure 6.5

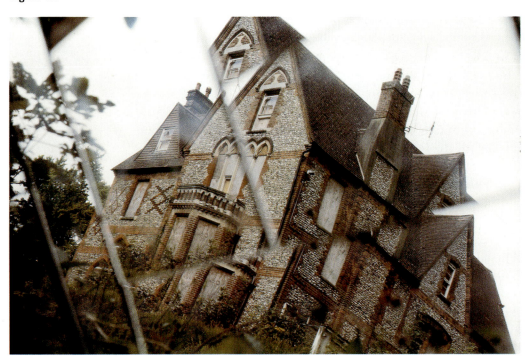

ties you faced. Obviously, your client should be forewarned that things have not gone smoothly. If a reshoot is required, this should not be done free of charge, but ought to be billed at a slightly lower rate as a professional courtesy (even though the original failure was not of your making).

Sometimes, the problem will be your fault – or, at least, not due to any failing on the part of the client or the job itself. You might arrive late for an appointment and find that your subject has left, or there might be a problem with your equipment or with the film. These are very uncomfortable situations to be in, but they do happen. To minimize the risks, use a Polaroid back to confirm that the equipment is working as it should be, and shoot at least two rolls of film to guard against processing problems. Needless to say, the two rolls must be processed separately for this tactic to be effective. If you miss an appointment, your only recourse will be to wait around until it is once again convenient for the pictures to be taken, or to return on another occasion – in which case the client must be informed if the delay will cause the pictures to

Figure 6.6 A private security guard attempted to stop me taking this picture. In such situations it is important both to know your rights and also to recall that 'he who snaps then walks away lives to snap another day!'

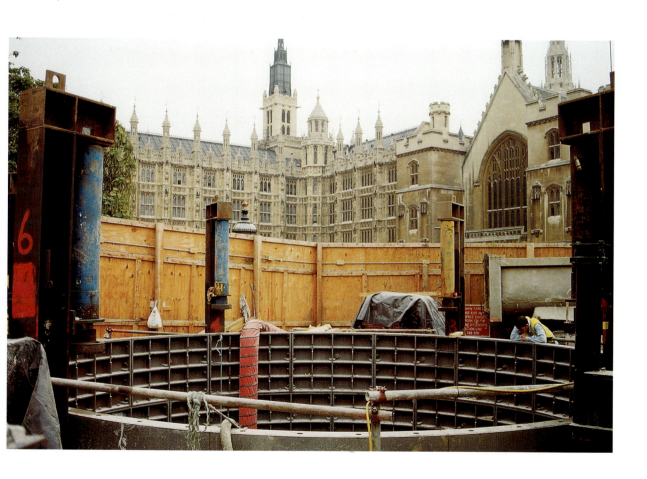

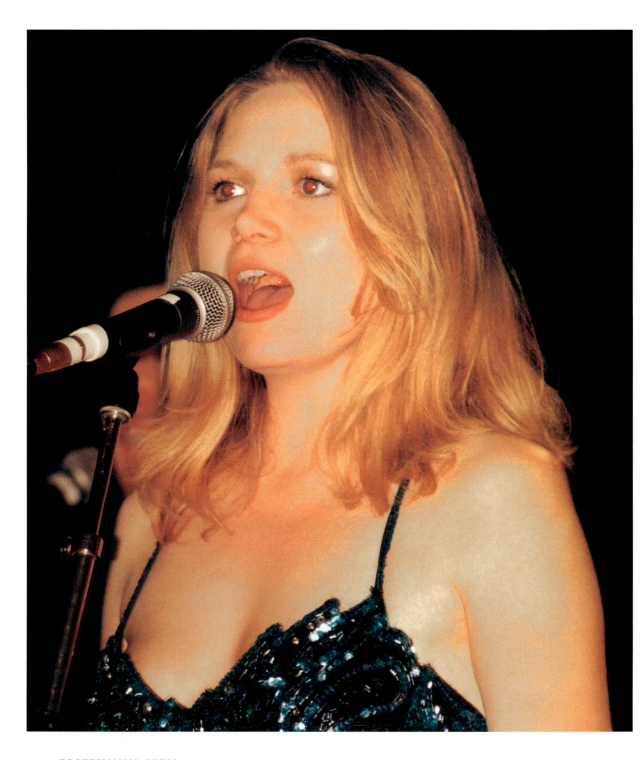

Figure 6.7 Two prints showing the improvement that can be obtained by treating a red-eye print with a red-eye correction pen. This is a very quick and easy retouching technique to master.

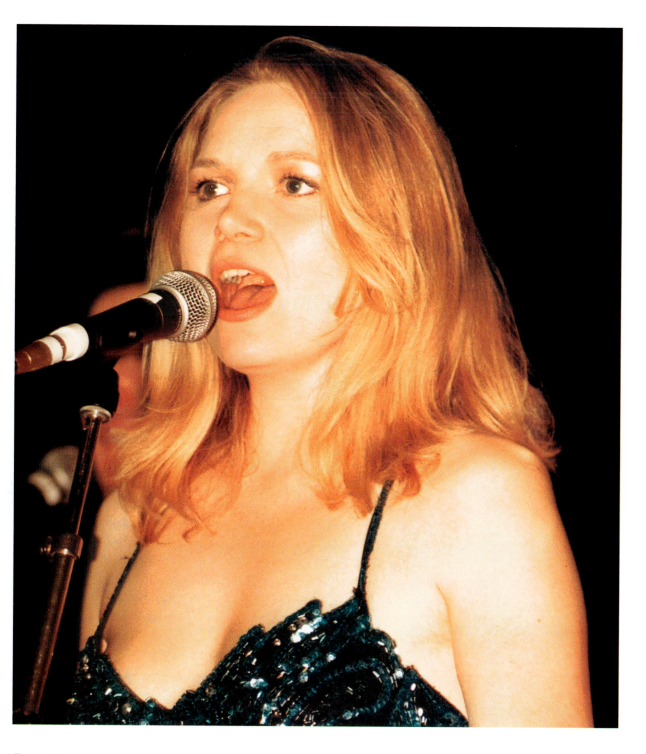

Figure 6.8

be delivered later than originally anticipated. You should certainly not increase your fee on account of having to make a return visit, and you might even decide to supply the entire job free of charge as compensation for the inconvenience you have caused.

Bad debts

Very occasionally, a client will refuse to pay an invoice that you have issued. You can often see these situations developing, for there will often have been a problem or some misunderstanding along the way. There are no hard and fast rules for dealing with such situations, but one good guideline is to check whether or not your pictures were used as intended: if so, then you will have a good case for claiming that pictures were good enough for the client to use, so they ought to be good enough to be paid for as agreed.

But before taking matters further, you should ask yourself three questions. Was the problem my fault? Even if it wasn't, do I want to keep the client happy? Am I too busy to get embroiled with legal proceedings? If the answer to any of these questions is 'yes', then you should simply bite the bullet and write-off the invoice. If none of the questions gets a 'yes', then you might want to pursue the matter even as far as the courts.

To proceed along this line, you should first send a reminder letter drawing attention to the overdue invoice. If the client has contacted you to dispute the invoice, you must set out why you reject the case put forward. If there is no response to the reminder, which should be polite and courteous, then you must send a 'seven-day notice'. This letter must say that if the invoice is not settled within seven days, you will apply to have the matter settled in court. You must also state that if the matter does go to court, you will apply for additional out of pocket expenses involved in bringing the action. Provided that the total amount is below the limit for the Small Claims

Figure 6.9 Fill-in flash is often employed in bright light when there are deep shadows, but can also improve many ordinary pictures too – provided that it is not overdone. Programmed fill-in flash operation copes with such situations very well.

Figure 6.10

Court procedure (you local courts will give you the current maximum figure), the legal route can be very easy and quick, and need not involve any formal legal representation (though your client may try to intimidate you with lawyers' letters). A useful 'last chance' tactic is to fax the court application documents to the client and to insist on immediate settlement if legal proceedings are to be avoided. In the event that the case does go to court, a judge will hear both your case and your client's, and will then will make a ruling that will settle the matter. No matter what the outcome, don't expect to work for that client again!

Although this has all been explained in the context of a disputed original invoice, similar difficulties can arise when a client exceeds the terms of a licence. It is often very difficult to catch a client doing this, and even harder to prove the unlicensed usage at a later date. Therefore, if you ever spy one of your pictures being used somewhere it shouldn't be, always get material evidence of the usage, even if this is only a photograph of the event.

Bad debts can also arise in the form of disputed claims for compensation if a client loses or damages a loaned original picture. The crucial point here is to obtain an admission of the loss or damage, and to have a minimum figure for compensation written into your terms of business. It is useful to be able to justify this figure, and the best way to do this is by stating that you would never sell all the rights to an image for less than the specified sum. By having lost or damaged the picture, the client has rendered the image useless to you, which is the same situation you would be in if you had sold all rights. Therefore, your loss is at least equal to your minimum all rights valuation. If you can prove that the picture concerned had special value, then your claim should be increased accordingly.

Although it is tempting to get aggressive with clients who dispute invoices, greater success will be had by using a more rational approach. Certainly, if the matter goes to court, the judge will want to hear a logically argued case, not just a stamping of feet and a waving of fists!

Laboratory problems

The other type of problem arises due to a mishap at the processing laboratory. Good laboratories know that things sometimes do go wrong, admit when this happens and take all steps to put the matter right. Thanks to electronic image manipula-

tion, there is little that cannot be rescued these days. But make sure that you are fair with the laboratory: if you have a back-up roll, don't fly off the handle just because the first roll has been damaged. Do, however, make it very clear that the second roll is the laboratory's last chance to get it right! A laboratory that makes a mistake then corrects the situation is better than one that relies on never making mistakes.

Beware of laboratories that claim something to the effect of all film being processed on the condition that its value does not exceed that of the unexposed material. A professional laboratory would be unlikely to succeed with this disclaimer in a court of law simply because it is the laboratory's job to process films that are of commercial value. Similarly, the Consumer Protection Act makes it unlikely that a high street minilab would get away with this in respect of the general public's films. However, and this is an important loop-hole, high street minilabs almost certainly will succeed in claiming that they cannot be held responsible for films of special (professional) value. The lesson, therefore, is always to use an appropriate processing service. Do not put professional films through cheap and cheerful processing lines unless there really is no other alternative.

A useful tip when ordering reprints from negatives is to give the laboratory only the film strip(s) needed to complete the order. Keep the other strips from the same roll(s) in a safe place. That way, if the laboratory loses its strips, you will still have something else to fall back on. It is a general principle that preventing problems is always better than trying to cure them after they have arisen.

Portfolios and awards

When people commission an editorial photographer, it is almost always on the strength of work done. Your portfolio is therefore one of your most powerful marketing tools. Few clients care whether or not you have won awards for your work, but many will be impressed by the right assignment history. A portfolio should therefore comprise the best examples of your work together with a list of your highest profile clients. Little significance is placed on the time span that your portfolio covers, but it is useful to make sure that there are a number of current examples: clients tend not to be impressed if they notice that your tear-sheets are all at least a few years old. Clients are impressed, however, by things like book and magazine covers. Some photographers cheat in this respect by

Figure 6.11 Polaroid test shot showing a simple product picture arranged within a mini-cove environment. The product itself – a clock made of cardboard – was, of course, framed very much tighter for the final picture (see opposite).

Figure 6.12

Figure 6.13 This portrait illustrates one of those unexpected problems that can sometimes arise when working on location: the picture was taken by window light, but overhead fluorescent strips caused a green cast to appear in the man's hair. Selective colour adjustment during printing (by Larry Bartlett) solved the problem (see opposite). Digital manipulation could have been used as an alternative method of correction, but would almost certainly have been a more costly route.

Figure 6.14

presenting pictures that have been used within publications as though they were front-page pictures. In my opinion, this is going too far.

As well as a collection of published examples, the portfolio should also show other styles of work. These are important because they lead the direction in which your business will grow. At one time, I used to do a lot of pictures for companies' in-house magazines, and because my portfolio contained a lot of those examples, that was the kind of work I kept getting. (Another contributing factor was the fact that clients referred me to their friends and associates who worked on similar types of publications.) As a result, things stagnated. I was stuck doing the same types of pictures for the same types of clients at the same rates of pay. Only by doing something different, and looking outside your usual field of activity, can this circle be broken.

A good idea for finding new clients was explained to me once by a photographer named Phil Jason, who used to specialize in trade magazines and exhibitions but has since expanded into stock photography in a very big way. His technique was to shoot cover pictures for trade magazines, or grand images that adorned exhibitors' stands at trade shows. He would then contact potential clients in a similar (but non-competing) field, and draw his work to their attention. In the case of exhibition stands, he would invite them to come and see his pictures *in situ*: in the case of magazine covers he would contact all the advertisers inside the magazine and use his cover as a portfolio image that had already been mailed out on his behalf.

Other very successful photographers favour personal publicity. Don Fraser was the king of UK industrial and commercial photography until he moved abroad. Fraser was a one-man publicity machine, describing himself as an 'internationally renowned photographer' and capitalizing on the publicity opportunities offered by every high-profile assignment that he did. Such an approach might sound brash and vulgar, but it worked. Everybody who mattered knew Don Fraser's name. Importantly, however, Fraser was also an exceptional photographer: editorial photography is not a field in which you can have hyperbole without talent.

Having said that awards are less important than commissioned work, awards do give plenty of opportunities for justifiable publicity. In addition, there are some awards that definitely are worth winning, including those given by the World

Press Photo Foundation (for everything from hard news to science and technology pictures), the annual UK Association of Photographers' Awards (for members only, covering both commissioned and personal work) and Nikon UK's Press Awards for all categories of newspaper photography, both individual images and picture stories. If nothing else, the quality and discipline demanded when entering awards is a useful antidote to the more humdrum nature of routine commissioned photography.

7 WORKING TO A BRIEF

The way of things in press, editorial and PR photography is very simple: a client wants a picture and you supply it. Unfortunately, this is not always a straightforward matter. It is quite common, for example, for a client to go to a picture library requesting a certain type of image, and to be shown dozens that fit the description – yet none might be exactly right. Imagine, therefore, how much harder it is to get the perfect picture when the client has to order a photograph in advance without the convenience of being able to choose the best from a selection that is already available.

Clients rarely know exactly what they want and are almost never fully informed about the circumstances in which their pictures will be taken. On other occasions, they will have particular ideas that won't work, or which are very vague. Nevertheless, the client is always right. The photographer should therefore aim to take three types of pictures; the picture the client ordered, a better picture in the same vein, and something a bit different. In the case of newspaper assignments, there are just two kinds of pictures that are needed; a duplicate of every image that every other photographer got, and an extra one that nobody else managed to get but you. The exclusive picture should be the best, of course.

There are seven things you need to know about any assignment:

1 What is the picture of?
2 Where is it?
3 What date and time?
4 Who is the contact?
5 What type of film?
6 What style of pictures?
7 When and where for delivery?

Figure 7.2 Pictures like this, where there are bright light sources within the picture, can only be taken successfully if you have very good lenses: anything less will exhibit severe flare that will ruin the photograph.

Figure 7.1 Having been sent to photograph a hospital Christmas party, I was very pleased to get this particular picture, but I suspected that it wouldn't be chosen for the local paper. Sure enough, the published image was of a little girl sharing a joke with a clown.

Most of these considerations will probably sound obvious, but all need close attention if the job is to run smoothly.

What is the picture of?

If the picture is to be a portrait, find out why it is being taken. This information will allow you to choose the most appropriate props and background. If it is for general use, choose a plain background: even a company logo can change within a short period of time and could immediately invalidate a picture. (There is a school of thought that says this is no bad thing if it brings repeat work, but clients rarely appreciate having do redo these sorts of pictures.) If, on the other hand, the portrait is to celebrate a particular event – which could be anything from the discovery of buried Roman treasure to the opening of a new warehouse – then clearly there should be something in the picture that tells this story.

I was once asked to do a portrait of a man who had written numerous letters to his local council complaining about vandalism to trees in a nearby park. At least, that was the story told to me by the newspaper, where it had been suggested that the perfect picture would be the man with a huge pile of letters. The problem with this idea is that the letters could be about anything, and a huge pile of them could imply that the man was simply an incessant nag without good reason. An additional problem became apparent when I

Figure 7.3 The view from the other side. A small pack of photographers vie for the attentions of a newly crowned beauty queen. The man in the middle (the best place to be) with his hand held up (a useful attention-grabbing trick) is Mirror photographer Mike Maloney.

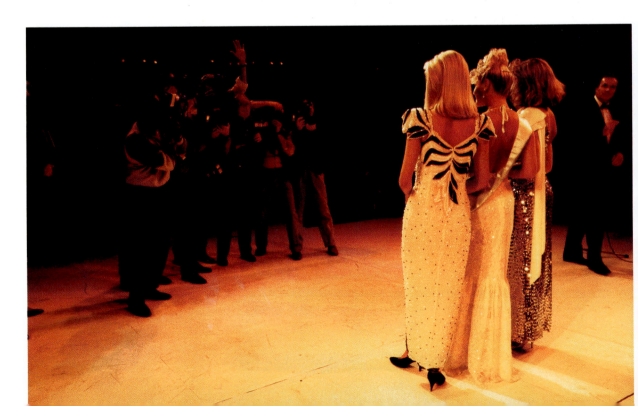

arrived: the man hadn't kept copies of his letters, so there was no pile to photograph (although one could have been faked). On talking to him, it transpired that the problem was not simply vandalism, but also the fact that the council was planting flimsy saplings that were very easily damaged. We decided the best picture would show both the man and a young tree. If we could find a damaged one, that would be absolutely ideal. As it happened, we did. But even if we hadn't, a healthy sapling would still have made the point. In the event, it was luck, in the chance positioning of the old man's dog, that made the perfect picture.

Equipment pictures are very much harder to anticipate than portraits. With people, there is often the ability to use different locations, but with heavy industrial plant this isn't usually possible. Therefore, one of the foremost considerations that apply is the setting in which the equipment is located. In particular, how big is the item and how much space is there around it? Taking a good range of lenses will help to give maximum flexibility when it comes to taking pictures, but even so it may be impossible to get the whole of the machinery in a single view. What do you do then? Obviously, if the client has specified something particular, then that will take priority. Alternatively, if the machine is a new one, then perhaps a view that shows the maker's name and model will be appropriate. Or if the machine performs a specific function, then that should be clearly apparent in the picture. Failing all else, simply choose the most photogenic angle.

If the picture is of an event such as the opening of a new office block or the switching-on of Christmas lights, then the obvious picture will show the celebrity involved cutting the ribbon or pressing the button. All you will have to do is be in the right place and fire the camera at the right moment. If, on the other hand, the event is something like a sponsored silence to raise money for charity, then you will have to come up with an interesting picture idea yourself. The smart thing to do is to think about possible visuals in advance, as soon as you know what the job will be.

Where is it?

There is no substitute for experience when it comes to anticipating the types of problems that can occur on location. Almost everybody has a tale to tell about going to the wrong address – the right street in the wrong district of town, or the wrong branch office. But just as bad is not knowing the

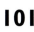

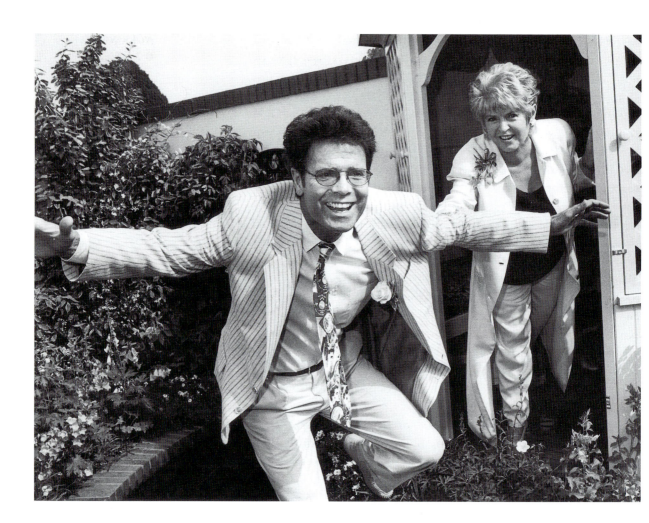

Figure 7.4 Celebrity photo calls often involve deliberate antics for the camera, but you still need to be quick to capture the moment. Photograph by Pamela Lee.

nearest place to park your car, or the closest train station when travelling farther afield. Always carry a map of the area, no matter how well you think you know the locale. Press photographers should keep in their cars (or camera bags) very detailed maps of all the areas they cover. Street maps must be up to date: there is little worse than planning a route to a job only to find a road blocked-off.

When driving in town, it is worth remembering that roads with speed-humps or width restrictions are likely to be useful short-cuts (that is the very reason why traffic calming measures are installed). In the country, distant roads can be easier to spot by looking for lines of trees or hedges, though these can also mark streams or rivers too! Always have a good idea of the general direction in which you are heading. A car compass can be useful, but in clear weather you can use the sun as a reference point, especially early or late in the day.

Incidentally, when travelling by car, beware of keeping cameras in the boot. First, this puts them out of reach if an unexpected picture presents itself and, second, it can cause condensation problems. The latter arise when cold surfaces come into contact with warm air – such as when a cold camera is used in a warm room. Even if the lens doesn't mist over, the eyepiece will be fogged by your warm breath. Batteries too should be kept warm if they are to give of their best performance.

On arrival at the location, there is the possibility of having to carry heavy items of photographic equipment up numerous flights of stairs, or the discovery that the church hall has no power supply into which you can plug your lights. These are all things you should know about in advance, so either remember to ask the right questions or – in extreme cases – do a reconnaissance trip before the shoot. The alternative is always to assume the worst: travel with as little kit as possible and use battery-powered lighting units instead of a mains-powered system.

Date and time?

'Next Saturday at eight-thirty.' So easy to say, so easy to get wrong! If today is Thursday, does next Saturday mean the day after tomorrow or the Saturday after that? And is eight-thirty a morning or evening time? You might think it is obvious which, but check to be absolutely certain. Getting out of bed early at the weekend to be somewhere twelve hours ahead of schedule is bad enough, but sleeping in and turning up twelve hours late is unforgivable!

It is also very useful to know the schedule surrounding the appointed hour as this might enable you to get an alternative picture before or after the main event. If, for example, there is a photocall for a hot-air balloon rally, then this may be several hours before the balloons get airborne. Not having the airborne picture could reflect very badly on you, but ignorance of the timing may mean that something else has been scheduled that precludes waiting for the launch.

Similarly, having to hang around should have cost implications, and such matters ought to have been clarified with the client in advance. Your client may have assumed that you knew the timing and had calculated your quote accordingly, in which case an inflated bill will be viewed very dimly indeed.

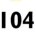

The worst kind of job is the open-ended one; standing outside somewhere waiting for a particular person to appear, or keeping watch on a fire-damaged building that might fall down at any moment. The person could have already left via a side door, and the building might not collapse at all. If you are on one of these types of assignments, be sure you know what you are being paid for – and make sure it is for your presence, not just for a picture that might never materialize!

Who is the contact?

This is your most vital piece of information. Make sure that you have both a name and a telephone number. As well as a name, get a job title, and if the number is a direct line then make sure you know the switchboard number too. Both these things are precautions against the person concerned being out or taken ill, and should allow you to be directed to somebody else who knows what is going on. An added advantage to taking the job title of your contact is that it tells you with whom you will be dealing. Is the person a celebrity's agent or the events manager at a venue or the managing director's secretary or the managing director in person?

Not only is your contact the person you ask for when you arrive, but he or she is also the person who you should contact if you will be late (or especially early) for any reason. In addition, your contact will probably know the answers to all those important questions about the subject, location and timing of the job. Don't be afraid to phone and clarify these details: you can never have too much information!

What type of film?

Surprisingly, perhaps, film has hardly been mentioned so far in this book. Even now, the most important question is only whether the job is to be done in colour or black and white, and whether the final pictures will be required as prints or transparencies. (Thanks to Scala, Agfa's black and white transparency film, all four variations are available off the shelf.)

Many commercial clients want their pictures supplied as colour transparencies. Newspapers tend to prefer either black and white or colour negatives, though *The European* did at one time make a big thing of preferring colour transparencies. Up-market magazines often like large format transparencies, especially where food and interiors are concerned. PR companies frequently go for colour prints, sometimes with a black and white back-up option too.

Even if the client specifies the film type required, it is worth checking that this is a considered decision and not just a matter of habit. Why, for example, would somebody want something shot in colour if it were a grey and black object photographed against a light grey background? The answer is that nobody in their right mind would go this route, but I know of one magazine that actually went as far as to reshoot some such pictures in colour because it was their policy only to use colour photographs: the fact that there was no colour in the images was immaterial. This sort of blinkered approach is impossible to predict. Fortunately, most clients are much more receptive to a photographer's input.

When pictures are being used in brochures, transparencies are often specified by the client because that is what the printer has asked for. There is a good reason for this, which is that transparencies can be scanned for reproduction to a higher quality than prints can (though this is not necessarily true when lower-cost scanners are used). Unfortunately, the format the printer prefers may not always be the best one for the photographer. Transparency films need to be used with great care if they are to give their best results, and unpredictable conditions can sometimes make this outcome very unlikely. Awkward subjects and uncontrolled lighting are therefore best not photographed on transparency films, no matter what the printer may prefer.

There are two ways of explaining this fact to a client. The first is to be very honest and to advise that, for various technical reasons, the pictures will look better as prints than they would as transparencies. This tactic is most likely to succeed if the client knows and respects your work. The second is to say that although a transparency might sound like a good idea, a print will give a very much better impression of the final effect because it is in the same form as the brochure (something that is viewed by reflected, rather than transmitted, light).

If the client insists that the printer has said the picture has to be a transparency, and you feel that a transparency will not give an acceptable result, then you can either decline the job, shoot the pictures on negative film and have them copied on to slides, or attempt to undermine the printer's authority. I have tried all three approaches in the past and can vouch that none really works. Turning down work is always hard to do, especially when it could have been avoided by a better choice of film; shooting negatives and

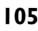

copying on to transparencies adds delay and expense as well as losing some quality; attempting to undermine the printer is simply taking too much responsibility for the entire job. The harsh fact is that a client who thinks he or she knows better than your professional experience is likely to be one who will cause you grief at a later date – probably because the pictures didn't turn out as envisaged for the very reasons that you foresaw!

Another interesting problem that can arise in connection with the type of film used is possible confusion between the words 'slides' and 'transparencies'. One particular client I used to have always insisted that slides were the things that were put into a slide projector (by this, the client meant 135 format slides) and that transparencies were anything bigger (conveniently dismissing the existence of medium and large format projectors).

When black and white pictures are required alongside colour, the best tactic is to use a similar type of film. Colour negative films are well matched to chromogenic black and white films such as Ilford XP2 and Kodak T400-CN, while colour transparency films sit well with Agfa Scala. Although film choice is primarily a personal thing, a few of my own favourites are as follows.

Kodak EPP is a very good all-round colour transparency film that gives good skin tones and bright colours. It lacks the over the top boldness of some slower films and works well when shot at EI 200 and pushed one stop during processing. Kodak's new E200 film also looks as if it will be a very useful emulsion, especially when uprated to EI 400. (At the time of writing, E200 is still quite new to the market, so firm recommendations are hard to make.) For tungsten work, Kodak 64T is the film to beat, but is rather on the slow side for many applications.

For colour prints, Fuji's films are the ones I prefer. Reala and NPH are two of the best. Reala is an ISO 100 film with soft colours and a very wide colour temperature tolerance that helps to minimize casts when shooting under mixed lighting conditions. For all-round use, this is a really great film – but some laboratories do seem to have difficulty printing it, which is a huge shame. NPH is the professional version of Fuji's ISO 400 print film. It has remarkably fine grain and gives natural colours. It also seems to work well with flash on account of its modest contrast level. For press work, Superia 800 is a 135 format film that gives excellent prints up to 8 × 10 in. Kodak

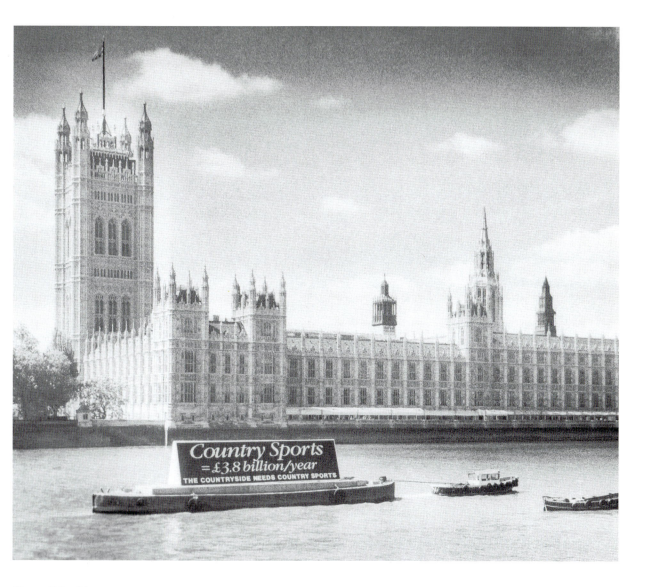

Figure 7.5 River protest outside the Houses of Parliament. Photograph taken on Ilford SFX film using a deep red filter to create a slightly surreal atmosphere.

now has a similar film, Ektapress PJ800, that is every bit as good. Even more extreme, and much loved by Paul Stewart, is Kodak Ektapress 1600: Stewart recommends exposing this film at EI 1000 and processing it as if for EI 2000.

When black and white pictures are needed, the aforementioned chromogenic and transparency films are ideal for use alongside colour emulsions. On other occasions, Fuji Neopan 400 is my usual choice. Depending on the developer

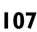

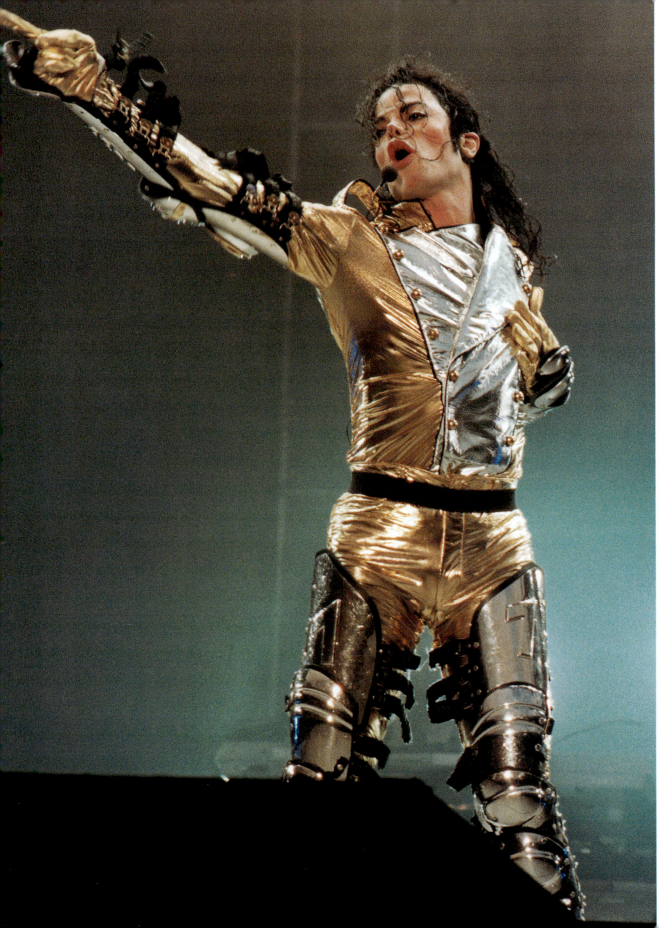

used and the effect required, Neopan 400 can be rated at anything from EI 200 to EI 1600. It really is a truly remarkable product. Also worthy of mention is Ilford SFX, which has extended red sensitivity and can give almost infrared effects without the handling precautions usually associated with true infrared films. I must admit that I haven't yet used SFX on a commissioned job, but I have tried it out thoroughly and am keeping some rolls of film (and the appropriate filters) in my camera bag for when the right opportunity comes along.

What style of pictures?

This is the trickiest question of them all. If you are given an open brief, then the client can always complain – however nicely – that the pictures aren't right in some way. On the other hand, a very specific brief leaves no freedom for experimentation. It can also mean the pictures take ages to do. I once did a job that had to be photographed one evening after a showroom had been closed to the public: we didn't finish until nearly midnight because the sketch I was working to had an impossible perspective given the available space. At the end of the shoot, the art director commented that my picture was the closest anybody had ever got to matching one of his drawings – at which point I bit my tongue!

Every now and then, somebody asks for 'something a bit different.' Experience shows that clients' ideas of 'different' are much tamer than photographers'. The odds are that if the picture is an executive portrait, 'different' simply means something other than a person seated behind a desk. If the job is a small product, it might mean using a different coloured background compared to the usual; if the subject is a bigger item of equipment, then it might mean using coloured lighting. Almost certainly, however, 'different' won't normally mean cross-processing the film or using an extreme wide-angle lens to create obvious distortion. To be safe, whenever anybody asks for anything 'different', always take something conventional too, just in case the client has a change of heart.

The other situation that arises from time to time is a client who has an example picture that he or she would like

Figure 7.6 Photographing music concerts is hard work on account of the limited time available. Frequently, press photographers have only about ten minutes to get their pictures. Photograph by Sofia Bartolini.

Figure 7.9 Pictures like this, of a school activity day, need to be taken with a minimum of fuss. Available light is much better than electronic flash in such situations.

Figure 7.7 Two different approaches to very similar assignments. When the people in the picture look towards the camera, the result is something close to a portrait, whereas when they look at the artwork the viewer's attention is drawn in that direction too.

Figure 7.8

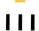

you to match. When this happens, you need to think very quickly to decide how the example was done, and whether you have the skills, time and budget to match it. There is a distinct possibility that the picture you are shown will have been taken under very different circumstances, or will have been the result of months of experimentation by another photographer. I always say to clients that I will try to do something as similar as possible, but warn that I can't guarantee to match the example exactly.

Personally, I dislike the idea of a client appropriating another person's idea and asking me to copy it. If clients want their pictures in a certain style, they should commission the photographer who produced the original images (if possible). In so doing, clients would find out what the pictures really cost to shoot, rather than simply assuming that they can be done for the usual budget. I say this not out of graciousness to other photographers or bitterness at inadequate budgets, but because I am especially uneasy that there might be clients out there showing my own pictures and asking other people to do something similar for less money. As I have written before, to do a job cheaper than somebody else is to do a disservice to both parties: to do it cheaper and to a lower standard is utterly depressing.

On a more routine level, the style of pictures required is often determined by the uses to which they will be put. Newspaper pictures almost always feature people – even if the story isn't really about them. Pictures that are taken for magazine covers must leave space for the title and other text. And, at the risk of stating the obvious, they must crop to the right shape! The same considerations also apply to book covers. Other pictures used inside magazines and books can be any shape, but you will notice that few photographs are ever used perfectly square. It is also a fact that horizontal pictures tend to be used larger than upright ones. To be more exact: it is possible to run an upright head-shot over a single column, but a horizontal portrait will normally be used over at least two columns. Public relations clients like to see their pictures big,

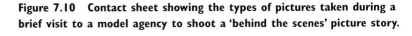

Figure 7.10 Contact sheet showing the types of pictures taken during a brief visit to a model agency to shoot a 'behind the scenes' picture story.

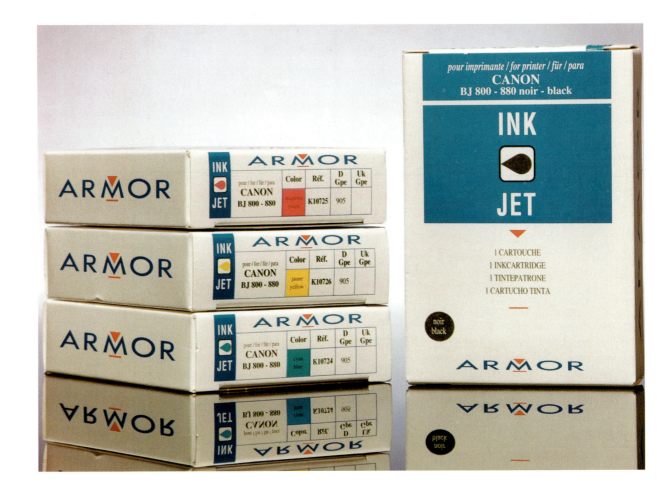

Figure 7.11 These boxes were arranged on a sheet of black perspex to create the reflections seen here. Filtered lighting was used to give a subtle pink colour to the picture, which was taken using a Mamiya RB67 loaded with Fuji Reala film.

and by supplying horizontal format prints you will help to make this happen.

Delivery – where and when?

If the pictures are delivered late, they will have to be exceptional to be regarded with anything other than a certain amount of disappointment. In the worst cases, late pictures will miss the publication's deadline. It is very unlikely that you will get paid if this happens: your ability to deliver the pictures on time will normally have been assumed when the job was commissioned.

When no special deadline is given, it can be useful to suggest a date to which you will work. It might well be that when one is mentioned, the client will say this is too late for a deadline that might otherwise have been taken for granted. Remember that getting the pictures to the client, or to some other destination, will itself take time that must be allowed

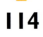

for. If at all possible, always deliver pictures direct to your client so you know that he or she will have the opportunity to inspect the work in person.

Occasionally, delivery relates to additional images (either extra frames of transparency film or reprints from negatives) that are ordered at a later date, after the original job. It is fair for you to allow a longer delivery time in such instances on the grounds that current work takes priority. It is also reasonable, as has been mentioned previously, to impose a minimum order to discourage clients from calling-in pictures one at a time.

Another way around this problem is to let the client have all the film, and to let him or her sort out reprints as required. Sometimes this can be a good idea, but it is generally better for you to keep the negatives. As well as helping to reinforce your ownership of the copyright, this tactic means that whenever the client wants further images, contact with you will act as a reminder of your existence – and that ought to help in terms of attracting future commissions. The times when this approach doesn't work are those when the job is one that you would rather do then dispose of in its entirety, or one that is undertaken for an overseas client, where communications and delivery can be rather slow (unless you use electronic means, of course).

8 LOCATION TECHNIQUES

Picture-taking situations divide into two categories. By far the largest comprises all those occasions when photographs have to be taken under prevailing circumstances on location. The other comprises 'studio' pictures, which might still be location assignments but which are undertaken within a more highly controlled environment.

Location photography is at the same time both easier and more difficult than studio work. Because most things are out of your control, successful pictures often come down to making the most of the situation. There is little for the photographer to do other than to choose the best background and lens, decide whether supplementary lighting will be needed, compose the picture and fire the shutter at the right moment.

Composition

There is no shortage of advice about composition for press and editorial pictures: unfortunately, quite a lot of it is complete and utter rubbish. Anybody, for example, who sets out to compose a perfect picture in the camera, and who holds with the philosophy that recorded images should never be cropped, is likely to have a short and very disappointing career in this field. With very few exceptions, photographers must get used to clients cropping their pictures both for impact and to fit the page.

However, subsequent cropping should be no excuse for poor original composition. It ought to be the case that the only reason why a picture can be made more dramatic by cropping is because the film format meant something had to be included in the frame when it would otherwise have been left out. Such cropping can also take place at the printing stage to remove extraneous details. In the days of prime lens domination, cropping was also needed to fill the gaps between different focal length lenses, but that excuse is now much less valid,

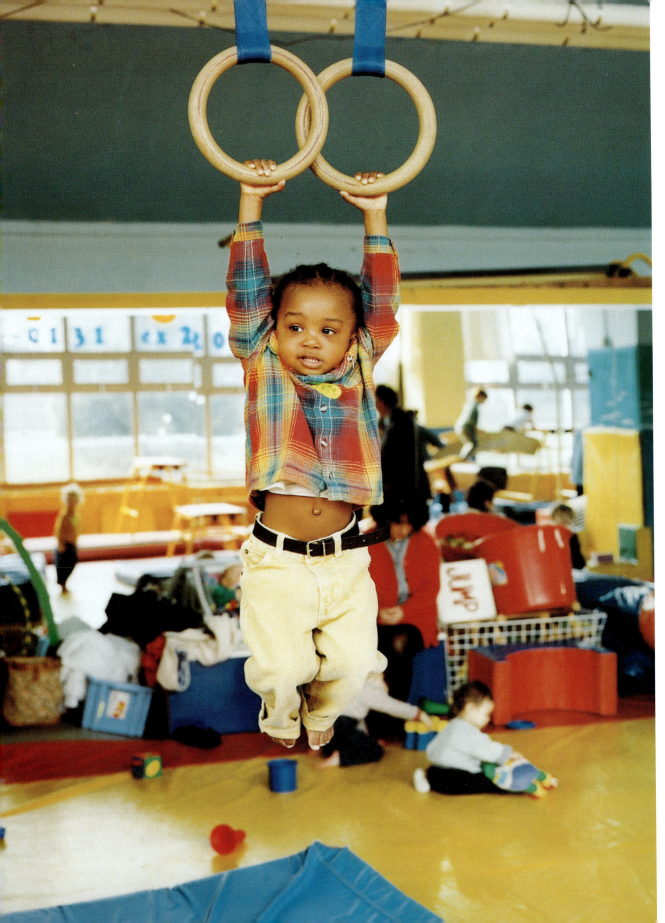

at least in 135 format photography where zoom lenses have become the norm.

In the absence of a zoom lens, one of the most useful pieces of advice that can be given is always to consider whether moving the camera back or forward (or up or down) would give a better view. In the world of hard news photography, the maxim is often: 'if your pictures aren't good enough, you weren't close enough to the action.' In other words, press photographers should get into the thick of things in order to capture the full emotion and immediacy of an event. For this reason, it is often better to use shorter focal length lenses, which have the added advantage of including a great deal of discernible background in the picture. Longer lenses isolate the photographer from the event, and also the action from its environment. If you look at good news photographs, you will notice that the background is often sharp and recognizable: shorter focal length lenses and smaller apertures favour such results.

Of course, there are times when it is useful to be able to separate the subject from the background. This applies most commonly when photographing sport, fashion in the street, and also at some types of photo calls. Longer lenses used wide open are best under such circumstances. Alternative pictures, which may possibly be even more interesting, can sometimes be obtained by deviating from this approach, but it is absolutely essential always to get the routine picture before doing anything different. It is also worth bearing in mind that, when working in a pack, sensible press photographers co-operate with each other by using the same or similar focal lengths. Using a shorter lens and moving closer, so obstructing other photographers' views, is not only downright rude but also a surefire way of becoming very unpopular and heavily bruised!

Away from the cut and thrust of hard news and mass photo calls, there will be many times when you will be the only photographer taking a particular picture. On these occasions, choice of composition and lens focal length is entirely free – within the limitations imposed

Figure 8.1 This picture is from a series commissioned to illustrate activities at a pre-school gym club. The hardest thing about the assignment was avoiding being seen reflected in the mirror that lined one wall of the gymnasium.

Figure 8.2 These two pictures have very similar framings but were taken from different positions using different focal length lenses. The longer lens gives a flatter perspective, though this effect is actually due not to the lens but to the more distant shooting position. Here, the lenses were an 80 mm (above) and a 150 mm (opposite) fitted to a Mamiya 7 camera.

by the prevailing circumstances. Knowing whether it is better to take a picture from a certain distance with a particular lens, or from twice as far away with a lens of twice the focal length, is largely a matter of experience. The four most important factors that come into play are the extent of the scene that is to be photographed, the available positions from which pictures can be taken, the perspective required and the degree of intimacy (or distance) required between the photographer and whatever is being

Figure 8.3

photographed. Perspective depends only on the camera position, not on the lens used. But in order to fill the frame, the focal length has to change for different camera positions – a fact that sometimes leads to the erroneous assumption that it is the lens that determines perspective. If truth be told, however, the most important factor that dictates the types of pictures that can be taken is the equipment you have brought to do the job.

Figure 8.4 A willing member of the public allowed this photograph, of a sponsored car wash, to be taken from inside the vehicle. The image was tidied-up during printing with slight cropping and by darkening distracting areas of the car's interior.

Press assignments

It is notoriously difficult to generalize about how best to cover press assignments. If the job is a photo call, the organizers will have specific ideas about the kinds of pictures they want you to take. On other occasions, one photographer will come up with an idea and everybody else will take the same picture. In such situations, it is a good policy to get some time alone with whoever is the star of the photo call in order to do an exclusive picture – though this is not always possible.

Hard news stories are very much every photograper for himself or herself. Riots, protests, crashes and bombings tend to present lots of different picture-taking opportunities, some more pleasant than others. Getting close to the scene of events can be difficult, not only because of police cordons and

hazardous situations, but also because you can become identified with protesters and rioters yourself – and could be arrested as such. Often, in order to be in the right place at the right time you need to be tipped-off about events – and that tends to mean having sources very close to those who might be engaged in illegal activities. Sometimes, you might feel that those activities are justified – perhaps if they involve releasing animals kept in captivity for testing cosmetics products – but if you are not careful your opinion could earn you a spell in a police cell. And if you are locked up, you won't be able to get your pictures to the paper, which defeats the whole object of the exercise.

A useful tactic is to take a few pictures on one roll of film, then to take that roll out of the camera and to replace it with another. Either hide the first roll or pass it to somebody else. If you are subsequently put in a situation where the film is taken from your camera, you will still have some pictures in reserve.

Obviously, it makes sense to be able to move quickly, so carry the minimum amount of kit that you can get away with. Typically, this will be two camera bodies (plus a third all-mechanical back-up if possible) and zoom lenses that cover 35–70 mm and 80–200 mm. A fully automatic flashgun and plenty of film will complete the outfit, all carried inside a spacious, but not too bulky, camera bag. Other, more specialist items such as longer lenses and step ladders should be locked away securely in the boot of your car until needed.

In many cases, it is best not to look too much like a photographer. Certainly, the days of painting 'PRESS' on jackets and helmets (when necessary) are long gone. Survival is hardly ever a matter of life and death, but it can be very unpleasant just to be sitting on the goal-line of a football pitch when some fans seem to think that a more entertaining sport is spitting on to your back. If you see sports photographers wearing waterproof jackets, that is one reason why.

Tip-offs play a large part when it comes to photographing celebrities 'off-guard', for only very rarely are these genuine chance pictures. In many cases, the photographer knows the celebrity concerned or a member of his or her staff. The idea that somebody can roam a major city waiting to snap celebrities in the street is mere fancy. It is true that if you walk through fashionable districts you will almost certainly see famous people out and about, but nobody really cares about such pictures. A photograph that shows a certain film star

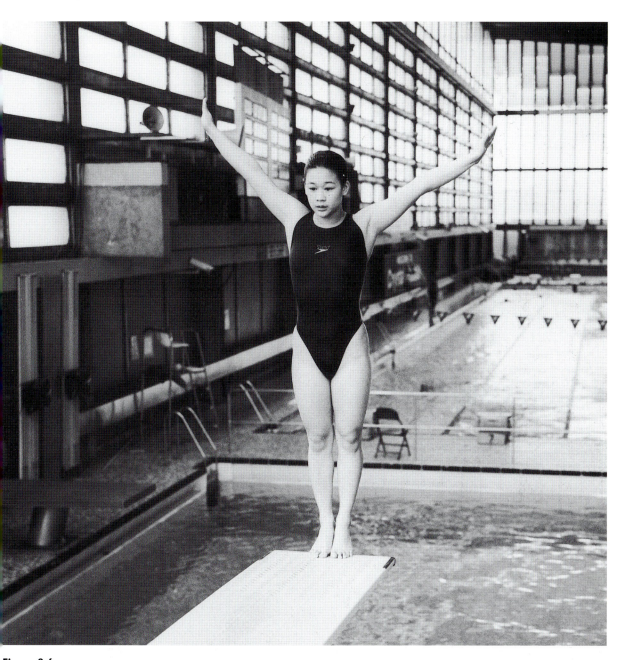

Figure 8.6

Figure 8.5 Three pictures illustrating some of the different viewpoints from which pictures can be taken. In this particular case, there is a side view, a view from above and a straight-on view photographed from the end of the diving board. In other situations, variations might involve nothing more complex than crouching right down on the ground or standing on a table or chair. For very low angle shots, it is useful if the camera's viewfinder can be removed to allow framing. Unfortunately, very few 135 format SLRs still offer this feature, though it does remain the norm for medium format cameras.

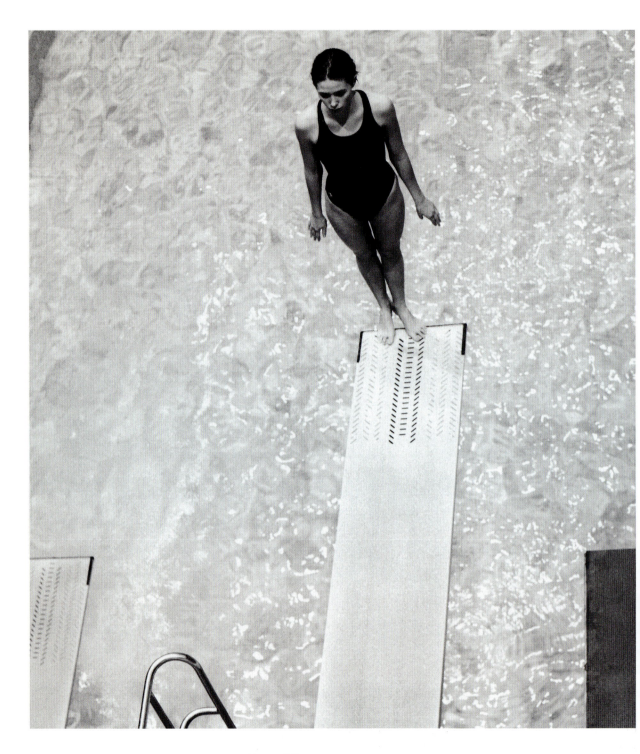

Figure 8.7

doing some shopping is of little interest unless there is some-body else significant in the picture, or unless the person has got fat, gone bald or whatever.

Feature and filler pictures are normally the most fun to do. They can involve anything from a clinic that deals in alter-native medicine to a talent show for pets; from the opening of a historic railway line to somebody who keeps old arts and crafts alive; from funny shaped vegetables to unusual collec-tors' fairs. All these things offer rich photographic opportuni-ties – all you need is the imagination to get an outstanding picture. Unlike other areas of press photography, you will nor-mally be dealing with members of the general public who are only too willing to do almost anything to get into the papers.

One very important point to bear in mind, however, is that filler and feature pictures are normally very specific to particular publications in terms of style. The same idea would be treated very differently by tabloid and broadsheet newspa-pers. Never lose sight of this fact – and, tempting though it can be, never supply an alternative picture from the same story to another publication unless you are free to do so. Newspapers take a very dim view of photographers who are supposed to be covering something for one title, but end up selling pictures to several. If you are a true freelance with absolutely no ties, and have covered an event on your own ini-tiative, then you will have a good case for making multiple sales from hard news pictures if nobody wants to pay for exclusive rights, but 'soft' pictures are a different matter. No picture editor wants to have to answer to his editor or pub-lisher about why the same 'cute and cuddly' photograph appeared on his or her pages and on those of rival titles. As always, you must look after your clients if you want your clients to look after you.

Products and equipment

Assignments of this type are commonly commissioned by trade magazines and PR companies acting on behalf of manu-facturers who want to show their items being used under real-istic conditions. There are four reasons why such jobs are often better done *in situ* rather than in a more controlled studio environment. As usual, the primary reason is often cost. In addition, the product may be too awkward to move, or there may be special value attached to the location itself. In a small number of cases, there may be security or safety factors that prevent the product from being relocated.

Leaving aside the question of cost, each of the other three reasons has its own implications for how best to approach the assignment. If the item is awkward to move, then any efforts needed to improve the look of the picture will have to concentrate on relatively simple lighting techniques. If the location is important, then the background must be clearly visible: occasionally, it may be possible to move the object slightly so as to make better use of the environment. If security or safety considerations dominate, then all photographic requirements are secondary, and it is often a wise precaution to advise the client of this fact before undertaking the assignment. The alternative can be to risk the wrath of an unhappy client when it turns out that the constraints of the situation made it impossible to take the kinds of pictures that were really wanted.

My normal kit for this sort of assignment consists of the following items:

- Mamiya RB67 with 65 mm, 90 mm and 180 mm lenses
- Polaroid back loaded with black and white instant film
- Lumedyne battery-powered flash system (400J)
- Radio slave flash trigger
- Exposure meter (flash/ambient)
- Colour and/or black and white negative film
- Tripod

It is perfectly possible to pack all of these items into two bags, plus the tripod, and to carry everything a reasonable distance on foot. This makes especially good sense when the location is in the centre of a city where parking can be a problem.

The reasons for choosing these items of equipment have already been explained in various other parts of this book, but will be summarized here in brief for convenience.

The medium format camera ensures good quality images, while its leaf shutter lenses allow maximum flexibility for balancing flash and ambient exposures. The Polaroid back confirms that everything is working correctly and also provides a good way of checking composition. Black and white instant

Figure 8.8 **Printing press lit with tungsten light using coloured gels to provide an eye-catching image that became a trade magazine front cover.**

Figure 8.9 Lit using electronic flash overall, but with tungsten spots highlighting areas of the machine for added drama. The picture was taken on daylight balanced transparency film.

film is loaded because it develops more quickly than colour. Using a battery-powered flash system avoids any need for a mains power supply: a wireless trigger avoids having trailing cables that can be hazardous. A good exposure meter is absolutely essential for quick working. If the meter plays up, Polaroids can do the same job but only more slowly and at greater expense. Negative film gives plenty of exposure range and allows some degree of colour and contrast correction during printing. A tripod ensures not only that there is no blurring when slow shutter speeds are used, but also serves to mark the picture-taking position for the benefit of other people who may be milling around.

The human element

Pictures of industrial equipment can be boring unless an operator or other person is included to liven-up the photograph. Unfortunately, this tactic complicates matters by introducing a less controllable, non-static element into the picture. Techniques such as dragging the shutter (setting a slow speed to pick up background illumination when the foreground is lit with flash), cannot normally be used in such situations. On the other hand, people give a sense of scale and can also be used to block unwanted parts of the background.

For best results, people should be posed as required, and not simply photographed wherever they happen to be. If the person in the picture is the machine's operator, then your first question should always be to ask where they would normally stand and what they would normally be doing when the equipment is in use. There is nothing worse than delivering a picture only to have the client complain: 'those people shouldn't have been standing there.' It is vital to remember that the equipment, not the person operating it, is the main subject of the picture. Therefore, anybody in the picture should probably be looking towards the equipment, not towards the camera.

Generally speaking, these sorts of assignments do not demand anything clever. The emphasis is normally on clean, sharp, well-exposed pictures that show the product and – often most important of all – the manufacturer's logo or nameplate. The image should be a balanced combination of good aesthetics and a convincing overall effect.

If Polaroids are used, and the client is present when the photographs are taken, then it is a very simple matter to ensure that the pictures match the original intention. Once

you are happy with everything, don't be shy about showing the Polaroid for approval: a client who is happy with the proof print is also likely to be happy with the finished result. Shoot the final pictures in duplicate on two rolls of film, then develop the rolls separately to allow for possible processing adjustments (as well as to help guard against problems at the laboratory).

Cover pictures

Trade magazines sometimes use product pictures on their covers. This may be because the product featured is novel or exciting, or it may come about because the manufacturer of the item has some sway over the magazine. But for whatever reason, the cover shot has to have all the usual technical qualities and be eye-catching too. Rarely will a straight picture be appropriate in this case.

One of the simplest techniques that can be employed to spice-up a cover is coloured lighting. This is easiest done by starting with the product conventionally lit so that it looks good on the black and white Polaroid. Coloured filters can then be placed in front of the lights to give the desired hues. By checking subsequent Polaroids against the original, you will be able to tell which colours are appearing lighter and which are too dark. (It is important to appreciate that an exposure meter may be misled by coloured lights, and that full-colour Polaroids may also misrepresent the colours – which is another reason why I use the black and white type.) As always, techniques such as this must be well rehearsed in advance before being used on a real-life assignment!

Portraits

If at all possible, I like to shoot all portraits using natural light. Ideally, this is not open-sky outdoor light, but is something soft and yet directional – the light that comes through a large window or an open doorway is often perfect. Sometimes I will add fill-in flash to lighten the shadows, especially within the eye sockets, if harsh sunlight cannot be avoided.

Although portraits can be done on any camera I like to use a 6 × 4.5 cm model. Such a camera is more imposing than a 135 format SLR yet is not as bulky as a larger format roll-film camera. For portraits, a standard lens and a longer focal length type are normally all that is needed. One problem that can arise, however, is not being able to focus close enough to the subject. To be honest, this is a purely personal thing

Figure 8.10 Because this photograph was taken on colour negative film, it could be printed in different ways. When the photograph was taken, the foreground was lit by tungsten light and the background was lit with electronic flash. If the print had been made normally, the background would have looked neutral and the foreground would have been very orange. But by adjusting the print colour, the foreground was made more neutral and the background was allowed to go blue. As a result, attention is focused firmly on the digital copy camera in the foreground, and not on the operator beyond – something that was helped by the use of selective sharpness at the moment of exposure.

because I like my portraits to be quite tightly cropped, and the bellows focusing of the Mamiya RB67 allows a much tighter framing than is possible using a twist-focus lens. As a result, I have a set of close-up accessories for those 6 × 4.5 cm lenses that I know cannot be focused close enough unaided.

But perhaps the most useful accessory of all when doing portraits is a soft-focus attachment. Provided that this is a subtle type, it can be used for all portraits regardless of whether they are of male or female subjects. I am particularly fond of black stocking softeners, but these must only be used when the lens is wide open. To use them at smaller apertures risks recording a visible crosshatch pattern on the picture. More flexible is the Zeiss Softar type, which can be used at any aperture but has the disadvantage of creating flare from very bright areas. But whatever type is used, a deep lens-hood must also be fitted to avoid a general loss of contrast. In addition, I try always to use a tripod when taking portraits simply because the shutter speeds tend to be on the slow side for the focal length of lens being used.

Events

In a way, events are mini picture stories (about which, see below). Rather than taking a single picture that encapsulates the brief in one frame, coverage of an event must show several different aspects of what was going on. It needs to set the scene and also to record particular highlights: it needs to show people en masse, and also a special one or two in particular. Your overall intention should be to make the viewer feel as if he or she had been there in person.

Figure 8.11 Nice pictures sometimes come unexpectedly. The occasion here was a visit by the Duke of Edinburgh to a bookshop in Cambridge: coincidentally, Tony Benn also made a personal appearance at the same bookshop, though not at the same time. This photograph was included in an experimental picture-based publication that was produced by Mirror Group Newspapers during the early 1980s. Picture Mirror attempted to recreate the spirit of the Picture Post, but failed to get off the ground.

Figure 8.12 Industry dinner events, in this case the presentation of Quickprinter awards, often include after-dinner entertainers. The polite way to proceed when photographing such people is to take just a few pictures then to get out of the way to allow the guests to enjoy the show. The best entertainers know how to play to the camera so as to get the pictures over with quickly.

The range of assignments that fall under this general heading covers everything from management trainees being sent to live under canvas for a week to enhance their team-building skills, via 'day in the life' stories, to receptions and gala dinners. The latter may sound singly uninspiring, but the difference between a particular industry's annual awards and high profile cinema and music presentations is only one of scale. All these occasions need to be photographed, both for posterity and as part of the publicity machinery that surrounds such events.

Rarely does coverage of an event stand or fall on your ability to obtain one single picture, though often there will be a particular image that is especially important. Sometimes this will be the climax of the event, on other occasions it will be something unexpected that everybody talks about afterwards. The first is easy to anticipate – provided that you get yourself properly briefed – but the second is simply a matter of keeping your eyes open at all times.

Your equipment should be minimal and quick to use, typically comprising the same items as would be taken to cover a news story. Never stop concentrating on what is going on around you. I well remember being at a society event where Alan Bond, the Australian financier, was tipped to be a guest. When he arrived, there were three of us outside: ironically, the other pair were busy discussing the merits of their various cameras' functions at the time – and so missed the picture.

This tale also raises another point, which is that you must try to recognize as many famous faces as possible. If in doubt, always take a picture. It is better to have surplus pictures of people who aren't famous than to have failed to spot somebody who is.

Picture stories

The thing that separates picture stories from coverage of events is the fact that the former are normally much more under your own control. Often, you will have come up with an idea, which may or may not be picked-up in advance by a client. In all probability, newspapers and magazines might say that they are interested, but won't commit to anything more than that until you come up with the goods. There was once a time when you would be given a brick of film to help you on your way as a mark of serious intent, but cost-cutting seems to have made this a rare gesture these days.

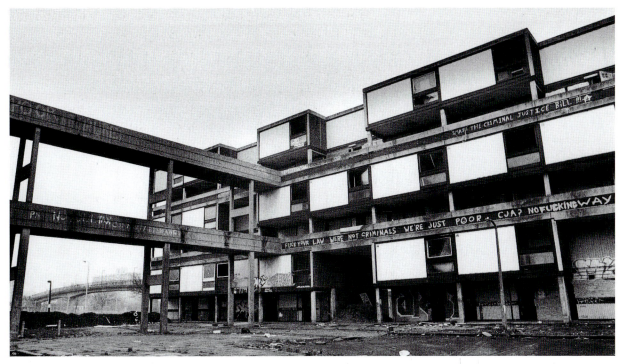

Figure 8.13 This series of pictures is a small selection from thirty images taken by Paul Stewart to mark as many years' campaigning activities by the homeless charity Shelter. An exhibition of the pictures toured photographic colleges during 1997 and 1998 thanks to support from the One-2-One mobile communications company. Stewart also visited the colleges in person to talk about press and documentary photography, and about picture transmission via mobile phone links over the One-2-One network.

Figure 8.14

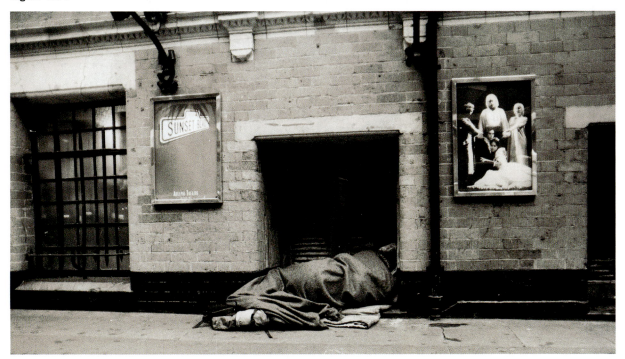

Figure 8.15

Figure 8.16

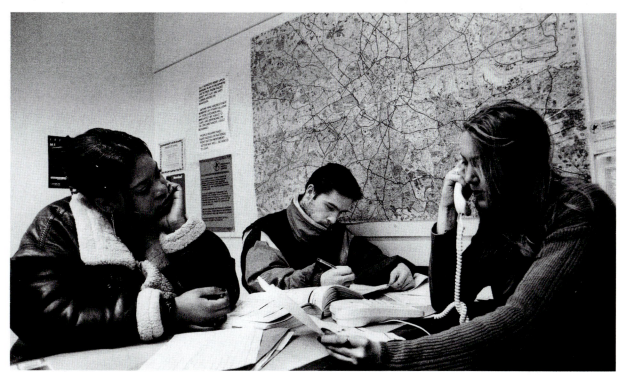

Figure 8.17

Picture stories are tricky projects to do. On the one hand, if the idea is a good one, why wouldn't somebody commission it in advance? If it is less good, will anybody ever buy it? The truth is that many more picture stories are photographed than ever see the light of day in print. And unless they sell to several magazines, even those that are published rarely make much money. Often, picture stories probably shouldn't be undertaken at all unless you really want to cover the subject – and would do so regardless of whether or not you earned anything from the project.

Choosing the right subject is also very difficult. Many things have either been done to death or just aren't fashionable. Back in 1982, I went to the Gaza Strip to shoot a picture story about the Palestinian refugees who live there, hoping that the Israeli invasion of southern Lebanon would give the project poignancy. When I returned, several colour supplements said nice things about the pictures, but all were of the opinion that it wasn't the story that mattered at the time. I had thought that doing something different would be a good idea, but it wasn't.

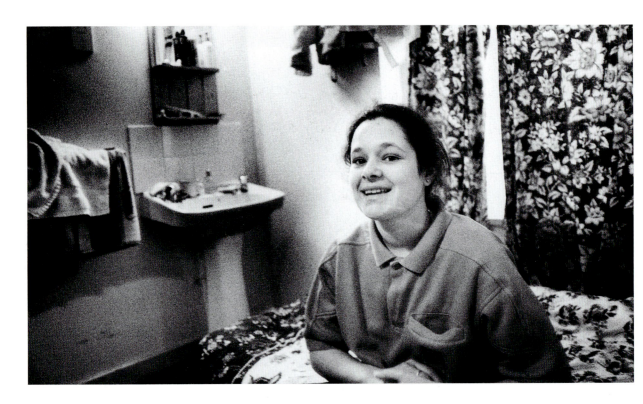

Figure 8.18

On the other hand, Tom Stoddart has said he feels that young press photographers don't think sufficiently broadly when it comes to choosing picture story ideas. 'A story on the homeless is not enough any more – it's been done too many times before,' he warns, suggesting instead that 'they'd be better off doing a day in the life of the Duke of Westminster.' Always assuming, of course, that the Duke would agree to such a proposal!

9 STUDIO TECHNIQUES

If all of your work is for newspapers, then the odds are that you will never need any of the formal techniques that follow. You might, however, still benefit from some of the general principles. Studio photography is all about control; about getting the lighting, exposure and composition exactly right. Although this ideal is rarely achieved outside a studio environment (and sometimes not even within it), the philosophy is still one that is worth pursuing for the positive effect it can have on the standard of your work in general.

On location the worry is often 'have I got the picture okay?', whereas in the studio this fact is taken for granted: the concern now is 'can this picture be improved any further?' That difference in attitude is the primary reason why all photographers should have at least a basic grasp of studio techniques.

Sources of light

One of the most important things that distinguishes studio photography from other types of work is the lighting, which does not rely simply on whatever happens to be around, but rather uses artificial sources introduced by the photographer. Those sources can be either continuous (usually tungsten lamps) or flash (normally electronic, but sometimes large, single-use flashbulbs). The overwhelming advantages of electronic flash are its natural colour, its relatively low cost and its convenience. Unfortunately, flash lighting is awkward to use because you cannot judge it by eye, and nor can you use in-built camera exposure meters. Neither of these drawbacks applies to tungsten lights, though these do have their own problems in terms of requiring more power, generating more heat and producing an orange cast that can ruin colour pictures. Because space is limited, and despite the fact that

Figure 9.1 By arranging the largest lightbox closest to the camera, and the smallest one farthest away, an exaggerated perspective has been created here. The lightboxes were lit using diffused flash, with the shutter speed kept sufficiently slow to let the lightboxes glow very slightly from the effect of their own internal tubes.

several of the pictures in this book were lit using tungsten lamps, the following equipment discussion applies specifically to flash systems.

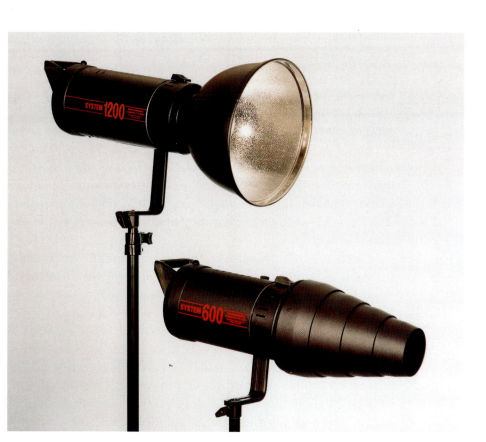

Figure 9.2 Typical monobloc flash units – these ones are Bowens compatible models that are made by Systems Imaging.

Leaving aside battery-powered units such as the Lumedyne, flash heads divide between those that plug directly into the mains and those that plug into a master power supply unit, which is itself plugged into the mains. If you have four of the former type, then there will be four plugs to be connected, whereas a single master power supply can normally drive up to four separate flash heads from one mains plug. Self-contained flash units are called monoblocs: those that use a master supply are called generator systems. By and large, generators are more powerful than monoblocs. In addition, the heads are smaller and all the controls are centrally located. Monoblocs are less costly for a modestly specified lighting kit, and are more flexible in that they can be purchased and used either singly or together in whatever quantity is required for the job in hand.

There is much less choice amongst generator systems than monoblocs: in the UK, the two most popular generator suppliers are Bowens and Elinchrom. Both these manufacturers also offer monoblocs, and are joined here by the likes of Multiblitz and Courtenay. There are also other alternatives, such as Strobex generators and System monoblocs, but these are less well known than the mainstream alternatives. Having said this, I am a great fan of Strobex equipment, and also own three System monoblocs (as well as Courtenay and Elinchrom units). Just because some makes are better known than others doesn't necessarily mean that they perform any better – or any worse, of course.

As is so often the case, deciding between different brands is largely a matter of personal choice, though there are some significant design features that can sway opinions one way or another. Of those mentioned, System monoblocs are the only ones that feature switched power levels. This is a nice touch in terms of speed of use, but does sacrifice a little in terms of fine control. I often use System monoblocs on location when quickness is paramount. Multiblitz, Bowens, Courtenay and Elinchrom monoblocs all feature continuous adjustment of power levels: Bowens' latest monoblocs have rotary control knobs on their side panels whereas the other three manufacturers place their controls at the back. Multiblitz favours electronic controls, while Elinchrom and Courtenay both use mechanical switches and sliders. Elinchrom offers the shortest power range but makes up for this with a very wide selection of light-modifying accessories. Bowens too has a good range of accessories, but Courtenay's range is distinctly limited by comparison. Multiblitz is the word leader in electronic flash, but Bowens dominates the UK market – with Elinchrom in second place.

After choosing the brand, the next decision will be the amount of power required and the number of units needed. You can do an awful lot with just a pair of 250J or 300J monoblocs, though a trio of 500J or 600J units would be even better. In addition, you will need a few light-modifying accessories, including a standard reflector for each monobloc, a small softbox (about 60 cm square) and a pair of honeycombs that provide medium and small pools of light. A larger rectangular softbox will also prove useful, though this may not need to be purchased immediately. You will, however, need some stands on which to place the lights. Everything should be packed away inside two or three carrying cases. Amazingly,

Multiblitz can supply a kit that packs into a single bag – though it is rather heavy and a little unwieldy.

Exposure

For reasons already mentioned, an exposure meter is essential when using studio flash. Sometimes, a basic meter will be included as part of an all-in-one lighting kit: such meters tend to be accurate but not very sophisticated. A better meter is worth considering but need not be a high priority. In the mean time, Polaroids provide a direct means of checking lighting far more quickly than could be done by taking numerous measurements with a basic meter.

Having said this, by far the most common way in which flash meters are used is to measure the incident light intensity. To do this, the meter is held at the subject position and the

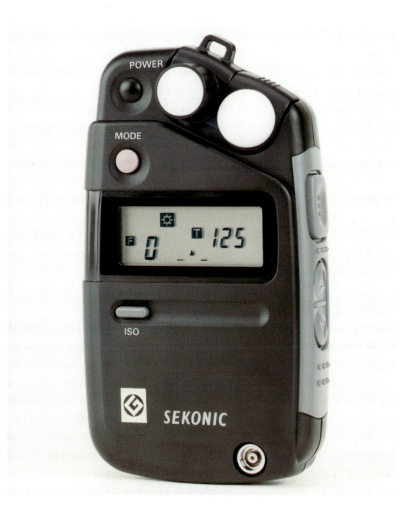

Figure 9.3 Sekonic flash meter. A hand-held meter such as this is essential for serious studio work.

white dome sensor is pointed back towards the camera. The lights are triggered, via a cable connected to the meter, and a reading is obtained. Provided that the meter is set to the appropriate film speed, it will display the correct lens aperture required for a normal exposure. At its most basic level, that is all there is to metering flash. Any flash meter ought to be capable of this function, and any picture taken using a reading obtained in this way ought to turn out reasonably well.

To move from a reasonably good picture to a better one, two other readings need to be taken into account. One is the brightness of the background; the other is the shadow exposure. To measure the background, it is best to take a reflected light reading. This can be done on all but the very simplest meters, either by sliding the white dome aside or by switching to a separate sensor. Normally, the aperture result displayed after metering the background will be different from the original (subject) meter reading. The magnitude of the difference will indicate how much an average tone subject will stand out from the background, and whether it will be lighter or darker than its surroundings. By altering the lighting set-up (or possibly the shutter speed – see below), it is possible to control this aspect of the picture.

To get a rough measure of the shadow exposure, which indicates how black the shadows will appear in the final photograph, return the meter to its original position, but shade it from direct illumination by the main light. Take a reading and note the result. The aperture displayed will be less than the original value, the amount less being a measure of the difference in brightness between the direct and indirect illumination. If a separate fill-in or 'base' light is used, the main light should be switched off when taking the shadow reading to prevent corruption of the measurement.

Lighting principles

In every lighting arrangement, there is one light that determines the exposure. Additional lights may be used to brighten particular areas such as the background, a person's hair or the maker's panel on a machine. In the best lighting arrangements, there will also be an extra light that prevents shadows recording as a dense black. This is the fill-in or 'base' light. Outdoors, on a bright sunny day, when harsh sunlight casts deep black shadows in people's eye-sockets, on-camera flash is used as a fill-in; in the studio, the fill-in light is not normally placed on the camera, but rather is a soft all-pervading light

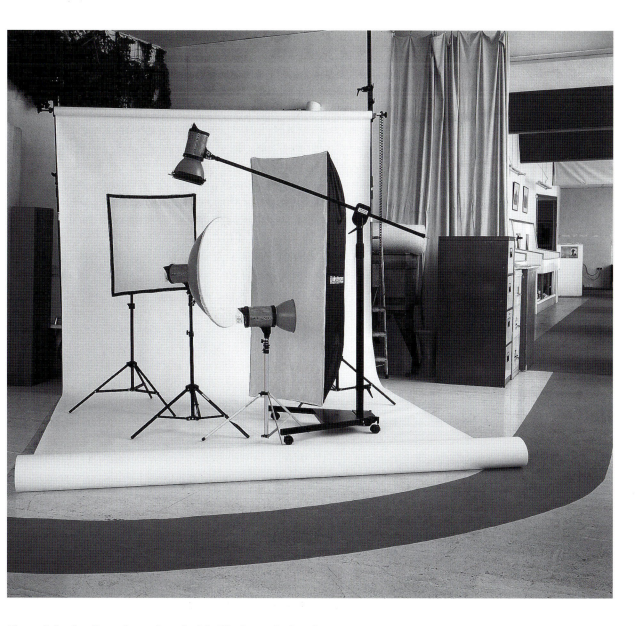

Figure 9.4 Small studio equipped with Elinchrom flash units.

that covers the entire studio to lighten every dark corner. An easy way to obtain this effect is to point a monobloc up into a corner of the room and to let the light bounce back to fill the entire space. This gives a much more natural result than using on-camera fill-in lighting. There is, however, one important proviso to be made, which is that the walls and ceiling must be white – or very nearly white – otherwise the fill-in light will give the photograph a colour cast that will be particularly

evident in shadow areas. (A deliberate colour cast introduced in this way can be very effective for certain types of more stylish pictures, but it is always something to be avoided in 'ordinary' photography.)

By changing the brightness of the fill-in light relative to the main light, the entire feel of the picture can be altered from something very moody to something light and airy. Normally, the fill-in light will be about one stop dimmer than the main light when using transparency film. When using colour negative film, the difference can be increased to about one and a half stops, while for black and white negatives it can be increased further to about two stops. These lighting ratios will all give reasonably natural results, though the black and white pictures will be the most dramatic – as is often expected of that medium. In certain circumstances, the lighting ratios may be higher than those given, but only very rarely indeed will they be any lower.

People pictures

Studio techniques are most often used in the current context outside a studio proper. It is relatively unusual for editorial portraits to be taken in a studio simply because the person's usual environment often forms an important part of the picture. Fortunately, all the usual studio lighting considerations still apply even when working out in the field (sometimes literally).

The simplest way to light a person who is in a small room that has a white or light coloured ceiling and walls is simply to use one light fired up into the corner. This gives a very soft effect with an absolute minimum of fuss, and can be metered by taking just a single incident light reading at the subject's position. Effectively, the picture is taken using fill-in light alone, but because there is no other light, the fill-in light is the main light in this case.

Regrettably, too few rooms are small enough or sufficiently neutral in colour to allow this simple approach to be used. The next easiest technique is to fit a small softbox on to one monobloc, and to place this slightly to one side of the camera. From the subject's position, if the camera is dead

Figure 9.5 A very simple studio style portrait that was actually done out on location. Two Courtenay flash monoblocs were used in front, with two smaller flash units (Jessop Portaflash heads) positioned behind to light the hair and the background.

Figure 9.6 Without the edge of the background paper and the flash units intruding into the picture, this would be just a strangely lit portrait. But as it is, the overall effect is quite stylish. Significantly, the person in the picture, Klaus Kalde, is himself a photographer turned black and white printer, so the inclusion of photographic props is particularly appropriate.

ahead at twelve o'clock on an imaginary watch dial, then the light would be slightly left or right, at about eleven o'clock or one o'clock respectively, and slightly above the height of the camera lens. Compared to using the corner light technique, the background will tend to record rather darker than before. In addition, there will be noticeably lighter and darker sides to the person's face. This effect can be exaggerated by moving the light further around to the side, or can be reduced by placing a white reflector close to the person on the opposite side to the light. The way to get the reflector in exactly the right position is to be perfectly clear about its function, which is to catch light that would normally pass by in front of the face and to direct it back on to the less well lit side. In effect, the reflector acts like a mirror, and light bounces from its surface in a similar way (but without specular hot-spots).

If you are lucky, a reflector will not be needed. The way to balance the lighting without a reflector is to use the ambient light level – provided that this does not have a heavy colour cast. Although a colour temperature meter is the most scientific way to assess the likelihood of any such problem, it is often enough just to look around the room and assess the situation with your own eyes. If there are plenty of bright windows and the room lights are barely visible in comparison, then the amount of daylight will probably swamp the colour cast caused by the interior lighting. If, however, there are no nearby windows, or the room lights appear very bright, then there will probably be a colour problem.

Assuming that the ambient light is suitable, fill-in can be provided by controlling the shutter speed while letting the aperture take care of the flash exposure. At the risk of insulting those who already use this technique on a routine basis, it is worth expanding on the details for those who don't.

Because flash units emit all their usable light within a very short period of time (around 1/500s or less), it doesn't matter what shutter speed is set on the camera provided that when the flash fires the shutter has fully revealed all the film area. The maximum flash synchronization speed on a focal plane shutter camera is the fastest speed at which there is an instant when the entire film area is all uncovered at once. (At faster speeds, a slit moves in front of the film to expose different parts of the film area consecutively rather than simultaneously.)

When slower shutter speeds are set, there is no effect on the amount of flash exposure received by the film because the

amount of light given out by the flash unit is fixed. A slower shutter speed does, however, increase the amount of exposure due to the ambient lighting, and by selecting an appropriate setting it is possible to give the desired lighting ratio through combined flash and available light. If, for example, an incident light reading of the ambient light level gave f/4 at 1/15s, and your lens was set to f/8 as determined by your flash reading, then using a shutter speed of 1/8s would give a soft one stop difference between the flash and ambient light levels. (To be safe, this tactic should be used only when shooting on negative film, so that if there is any slight colour cast, it can be corrected during printing.)

A similar approach comes into play when photographing a person sitting at a computer terminal, or in a location where there are television screens visible in the picture. Any scene that features a screen needs a minimum exposure of 1/30s to record a full picture without black lines. If the screen is displaying a moving image, then anything much longer than 1/30s will give a blurred result, so all such pictures have to be taken at about 1/30s. If the picture is static, then slower shutter speeds can be used to brighten the screen, but this tactic cannot be used otherwise. Clearly, pictures that include screens are ones where the ability to check everything with a Polaroid can prove very useful indeed.

Product pictures

Clean pack-shots and small products can be photographed in at least three different ways. One technique involves creating a scoop of paper, which forms both the 'floor' of the picture and also the background behind. The products are arranged as required, and are lit using a large overhead softbox. If a flap is attached to the farthest edge of the softbox, the background can be graduated into darkness. Obviously, the softbox must be sufficiently high for the flap not to intrude into the picture – though it must also be reasonably high anyway to prevent the uppermost surfaces of the products being overlit. Ideally, the softbox should be on a stand that allows it to be rotated to point slightly forwards rather than straight down. A low-level reflector is then placed in front of the products to throw light back into the shadow areas. Alternatively, a soft all-round fill-in light can be used for this purpose, as outlined previously.

The second technique involves using a fibreglass shell, known as a cove. Very large coves are used for fashion photography and in car studios: a table-top version, called a mini-

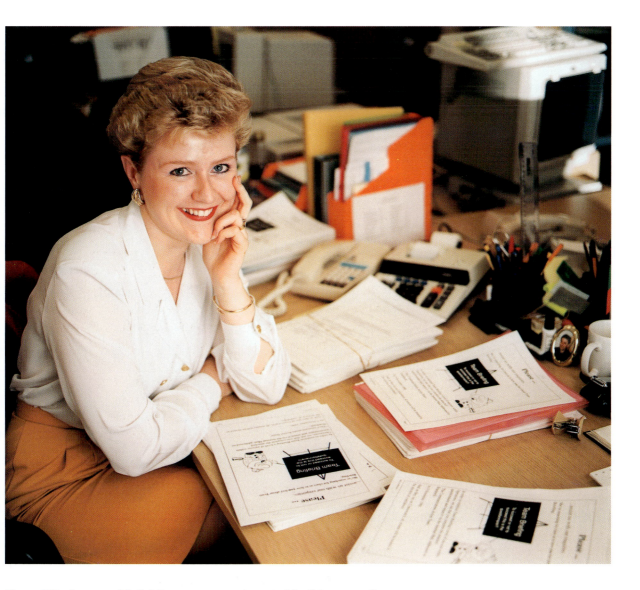

Figure 9.7 A very quick lighting arrangement created by firing a small flashgun through a white (Lastolite) diffuser panel. The flashgun was set to manual control, and the exposure was measured using a hand-held meter.

cove, is also available and is the ideal setting in which to photograph small products. A particularly convenient fact about the mini-cove is that it can be used standing upon a dining-room table, and doesn't need a full-size studio environment. Be warned, however, that although the mini-cove might sound small, it takes up about the same space as an armchair, so think carefully about where it will be stored if you work from

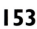

Figure 9.8 The Lumedyne battery-powered flash system being put to work in a location where trailing power leads would have been impractical – and dangerous.

home! All that is needed by way of lighting is a single monobloc fitted with a softbox and placed directly on top of the mini-cove's opening. Provided that the cove is kept clean, and repainted with white emulsion whenever it becomes soiled, small product shots should be a very straightforward matter.

The third technique is the 'floating' pack-shot, which is achieved by photographing the object on a sheet of glass secured above a paper background. Heavy objects should be photographed on smaller sheets of glass, while lightweight objects can be photographed on bigger sheets. In general, the

bigger the sheet, the more freedom you will have when it comes to arranging the lighting, which will normally be set up separately for the background and for the product itself. Because of this, and unlike the other two alternatives, floating pack-shots are almost never successful when lit with a single light.

If a smooth background tone is required, the background lighting should come from a small softbox. This is normally placed under the glass sheet, pointing backwards and flagged to avoid lighting the bottom of the product. If a more moody background is required, then a honeycomb can be used to give a brighter patch of light in a darker surrounding area. Although the background paper is normally white when a true floating effect is the intention, other paper colours can also be used – and can be complemented with coloured lighting filters if required.

The product can be lit either from above or from the front using two heads arranged almost in copy lighting fashion. An overhead light should be as small as practical in order to minimize reflections from the glass. If a softbox is used, a smaller 60 cm type is likely to be more successful than a large rectangular one. Reflections can be further reduced by using polarizing sheets. These can be cut to size and fitted over the lights (even a small softbox), and are complemented with a polarizing filter fitted to the camera lens. By rotating the camera polarizer, you will be able to control reflections that would otherwise be impossible to tame. Be warned, however, that large sheets of polarizing film are relatively expensive and are easily damaged by excessive heat. In addition, using double polarization over the lights and the lens will lose about two stops of light.

As far as larger products are concerned, the one guiding rule is that such items should never be lit as a whole, but rather should be lit in areas that create pools of light and shade – no matter how subtle these may be. It is likely that there will be at least two large area lights (softboxes or white panels on to which lights are shone to reflect back towards the product) as well as a general fill-in. Smaller local lights will draw attention to particular areas: often it can be useful to filter these lights very slightly, or to use tungstens that will give a warm glow.

Metering is rather more complicated when there are several lights, each of which illuminates a different area to a different degree. Polaroid facilities are particularly useful

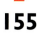

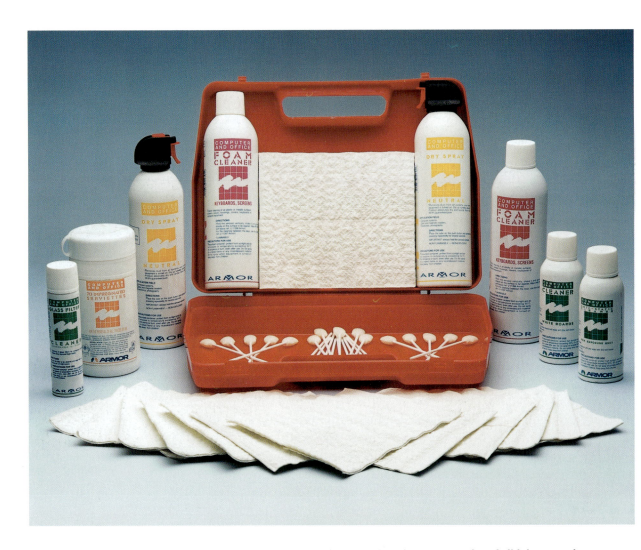

Figure 9.9 Pack-shot lit with an overhead softbox (above). When this picture was taken, I didn't own a boom arm system, so I devised a way of supporting an overhead light using a floor stand and two ceiling poles (as shown opposite).

here, especially for identifying specular reflections due to the lights themselves reflecting from smooth surfaces. It is relatively easy, just by firing the lights by hand and observing likely problem areas, to spot such reflections in flat surfaces such as panes of glass. However, trying to spot all the reflections in curved polished wood and metal surfaces is very much harder without the help of a Polaroid print.

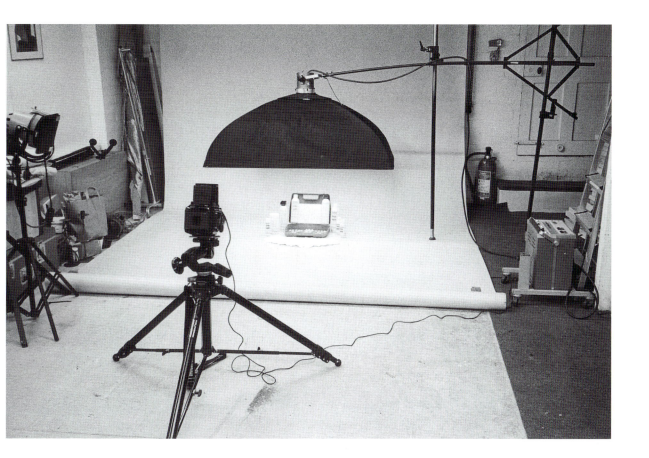

Copy lighting

Standard copy lighting can be used for absolutely everything from portraits and products right through to its proper intended purpose. Although the results it produces tend to be rather flat for three-dimensional objects, nevertheless it is a good stand-by technique for when all else fails.

The essential feature of copy lighting is totally uniform illumination right across the subject area. This is achieved by placing one light to each side of the camera, both set to the same power level and both aimed on to the subject at a forty-five degree angle. When photographing glossy artwork, it is especially important that the lights are as small as possible while still giving even coverage. This is for the same reason as applies when photographing objects on glass, which is that smaller lights are less likely to cause hot-spots on a smooth surface. I normally use standard reflectors when copying artwork up to about A2 size.

Figure 9.10

**PROFESSIONAL PRESS,
EDITORIAL AND
PR PHOTOGRAPHY**

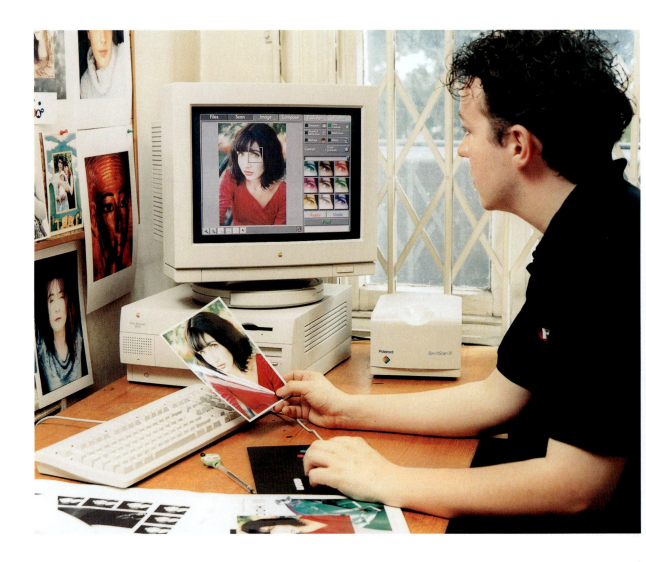

Figure 9.11 One of the hardest things to include in any photograph is a live VDU screen. In this case, there is a VDU screen and an outdoor window: the room itself was lit using electronic flash. Balancing all three to give the desired effect involved careful metering and judicious use of shutter speeds, apertures and flash power levels. A Polaroid back makes life easier in such situations, though one wasn't actually used in this particular case.

The quickest way to arrange everything for copying is to fix the artwork to a vertical wall, then to measure the height of the centre of the artwork and to set the centre of the lights and the centre of the lens at this height. The lights and camera should be horizontal: the lights can be set level by eye, but the camera should be set using a spirit level. Position the lights at

about forty-five degrees (again, judged by eye) pointing towards the artwork. If your lights have a brolly-mounting tube that runs through their length (as Courtenay's do), then you can sight through this to aim them correctly. When the lights are both at the same angle, you will see a hot-spot from one when you look through the other. This is a useful check, for the probability is that if the hot-spot is obvious when viewed so far off the camera axis, then it will be invisible when you look through the lens.

To position the camera, one trick is to stick a small mirror to the middle of the artwork, then to place the camera so that you see its image in the mirror when you look through the lens. This is a great idea in theory, but overlooks the fact that it isn't normally possible to stick anything to the artwork without leaving a mark or causing surface damage. The safer technique is to use trial and error, relying on the knowledge that because the lens is already at the right height, all that will be necessary is some experimentation in terms of moving the camera position left or right until the image is perfectly square.

To judge which way the camera should be moved, check to see whether the unsquare viewfinder image is smaller on the left or on the right: whichever side it is, the camera needs to move that way, then to be twisted back to aim at the centre of the artwork once more. The only complication that arises is the problem of remembering that medium format cameras have images reversed left to right when viewed through a waist-level finder.

Practise, practise, practise

The great thing about studio techniques is the fact that they can be tried out at almost any time. You don't need to be commissioned to copy some artwork to have a go at it. Nor do you need the compulsion of an assignment to try out a floating pack-shot. It is a shame that the same is not true of other types of editorial work, but the fact is that if you are sent to cover the British Grand Prix, you will get, at best, only one day of qualifying drives and the day of the race itself. That is why specialist fields like this tend to be served by specialist photographers. Studio work, on the other hand, is something that everybody can master – subject to sufficient patience and determination. Better still, studio assignments can be set up and repeated as many times as it takes to get the job right (within certain limits). There is no doubt

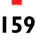

that studio photography can be scary at first, but simple assignments could become your most welcome money-spinners once you have got the appropriate techniques under your belt.

10 CAREER SPOTLIGHTS

Rod Ashford

Rod Ashford started his working life as a professional musician. Predictably, therefore, his first photographic forays were in the music world, though it was to the picture agency Allsport that he turned for advice before going professional.

The guy there told me that in order to do a particular thing well in photography, you need to have an interest in that thing. If you are interested in sport, you will already be reading all the sports magazines and you will know what sorts of pictures are being used. What he was talking about was having a visual awareness before you even own a camera. I've often thought how true that is in many areas of photography. He was also the first person I can remember saying that a camera is just a box with a lens on, and that without decent optics your pictures are going to look rubbish whatever you do.

I read all the books on photography in my local library. Then I just did this thing about knocking on enough doors to one day get in. I used to spend Saturday nights and all day Sunday doing pictures of celebrities opening fetes and things like that. I'd then rush into the darkroom and make some prints so that on Monday morning I could go out to all the local papers and ask if they wanted pictures of the things I had covered. It was important that I didn't just get the picture. I also got all the names of the people and a quote. The whole thing was a complete package. The papers didn't really want to pay, so I did it for a by-line at first. That isn't a sustainable situation so I had a part-time job to pay the rent. I think it's important to say that you can't have a part-time attitude to photography: unless something has your full commitment, even if you

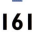

Figure 10.1 An exceptionally successful hand-coloured picture that has been used editorially and for book jackets and posters throughout the world. Photograph by Rod Ashford.

do something else to pay the rent, you can't do it on a professional level.

Ashford has since moved away from press photography towards studio based work. 'I'd always been attracted to the idea of photographing models – it goes back to what the guy at Allsport said about doing something that interests you. The real turning point was when I got my own studio. Previously, I'd been working from home, but you can't have clients or good models come to you at home.'

Now working as part of a husband and wife team, the bulk of Ashford's current work is for book covers and magazines.

We wasted a lot of time pursuing the calendar market. More than anything else, you've got to look for your niche, find your own level, and stick at it. A lot of people I knew in the early days didn't make it because they weren't prepared to go through living on a small income. A lot of our success was due to constantly going into newsagents and seeing who was publishing what, then sending similar pictures off to them. To be honest, it still is.

Roger Bamber

Best known now for his feature pictures in *The Guardian*, Roger Bamber's first job was as a staff photographer on the *Daily Mail*. This exceptionally fortuitous start was thanks mostly to good timing – being in the right place at the right time. Bamber had arrived in London from Leicestershire and had gone straight to the *Daily Express*, from where Terry Fincher had referred him to the *Daily Mail* knowing that the new art department there was actively seeking fresh photographers. That was in 1965. Four years later, Bamber was head-hunted to join Rupert Murdoch's new national tabloid, *The Sun*. Nineteen years after that, on April Fools' Day 1988, he was 'given the opportunity to get out' – and took it.

'I was absolutely terrified,' he admits. 'I'd never been freelance before and I had a large mortgage.' Initially, he worked for the weekly *Observer* newspaper. Later, he returned to national dailies as the south of England photographer for *The Guardian* – the position that he still holds today. In addition,

Figure 10.2 One of the portfolio of pictures that won the Nikon Features Award of 1992. Photograph by Roger Bamber.

Bamber also works for the National Trust, the Worldwide Fund for Nature and Brighton University, shooting both black and white and colour. 'You have to do those sort of things in this day and age – you can't have all your eggs in one basket.'

Although he accepts that digital photography plays an important part in newspaper work, it isn't something that he uses himself – except as a means of transmitting urgent pictures when time is short. Normally, his pictures are sent by courier from Brighton to *The Guardian*'s offices in London.

For others who are tempted to go the freelance route, Bamber warns that it is a solitary life compared to the camaraderie of the pack. On the other hand, a lot of organized photo calls are now heavily orchestrated, destroying the individuality of the photographer's eye. 'One person will come up with an idea and everybody will copy it. The next day, the papers will all be full of exactly the same pictures,' he laments. The significance of this is that it goes against the one thing that Bamber values above all other qualities in a photographer. 'You have to have a different way of looking. Nothing is new – it's how you interpret it that matters. You need the idea in the first place before you even start to think about how it will look on the page – or about how you will get it there.'

'Students at college think that to be a photojournalist is all glamour – which nobody did when I first started – but easy it is not. Even if you've got a well-known name, it doesn't all land in front of you on a plate. But if you enjoy it, stick at it.'

Chris Bennett

With a dozen picture-based books to his name so far, Chris Bennett has been granted behind-the-scenes access to some of the most desirable photographic subjects imaginable, including the Red Arrows aerobatic squadron, the Benetton Formula 1 racing team and life aboard the aircraft carrier USS *George Washington*. Yet Bennett's start in the world of full-time editorial photography was only prompted by redundancy from his previous job as a video editor for the satellite broadcaster Screensport .

'When I started, I had no background in stills photography, just an interest in aviation. One day, I phoned a US Air Force base about the possibility of a tour, and I was told that such facilities were only made available to people making films or writing books.' Bennett latched on to the book idea and started projects on one American and one Canadian base. Having got these two books published, he was then better able to explore a wider range of subjects, and has since photographed a book recording the 1994 Camel Trophy, two on the Lucky Strike Suzuki motorcycle team (documenting the 1993 and 1995 racing seasons) and a book entirely dedicated to the Lamborghini Countach.

Figure 10.3 Cockpit view inside one of the Red Arrows during formation training. Photograph by Chris Bennett.

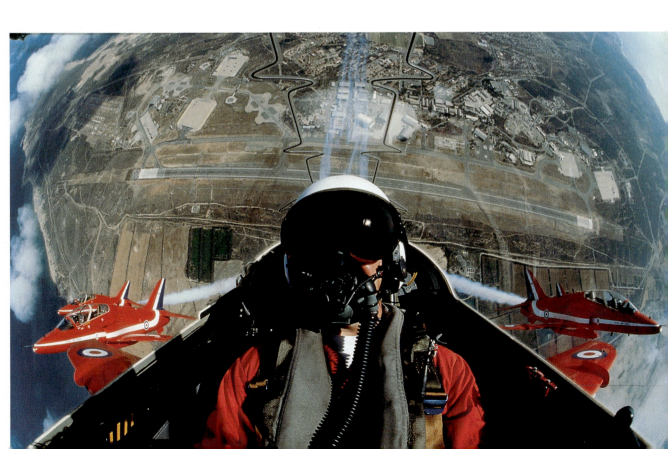

Because of their intended use, the overwhelming majority of Bennett's pictures are colour transparencies. And because of the circumstances in which they are taken, the pictures are invariably 135 format. Although his Nikons offer autofocus facilities, this is rarely used. 'It just isn't quick enough,' he explains. 'There are shots that you might miss if the AF doesn't lock, and I don't really want to risk that.' Air-to-air pictures are mostly taken using a 35–70 mm zoom, with wider lenses used for cockpit shots. On the ground, and when covering motor sports, longer lenses are used: Bennett owns a 300 mm f/2.8 lens, but hires more extreme optics as and when they are needed. Digital photography plays no part at all in Bennett's work at present, and nor is it expected to in the foreseeable future. 'In newspapers, you need pictures quickly, so obviously digital is useful there, but that just doesn't apply with books,' he explains.

Bennett's advice to photographers just starting out on their careers is not to expect life to be easy.

> You need real tenacity. Unless you're very lucky, it takes a lot of knocking on doors before one opens. The push is the most important thing: talent is important, but all the legwork is more important. If I couldn't take the knocks, I'd have given up years ago. There are an awful lot of people out there, but there are still an awful lot of things that haven't been covered. There are good livings to be made in photography, but only very few people get them.

Ken Lennox

Ken Lennox had his first photograph (a sports picture) published when he was just thirteen: it appeared in the Glasgow *Evening Citizen*. He subsequently flirted briefly with economics, but left college in his second term to join a local press agency. 'We did passports and goodness knows what when we weren't doing press work,' Lennox recalls. At the age of nineteen, he joined the staff of the Scottish *Daily Express* and moved from his native Glasgow to Aberdeen to cover the territory from Dundee to the Orkneys and the Shetland Islands. Around that time, the three *Daily Express* offices, in Glasgow, Manchester and London, employed in excess of one hundred photographers. There were thirty-one in Scotland alone, with overseas photographers in such places as America (both east and west coasts) and France. Today, staff numbers are much lower. Agency and other non-staff photographers are now very much more common.

Lennox was later head-hunted to join the staff of the *Daily Star* in Manchester. He then went to the *Mirror* in

Figure 10.4 The original colour version of this picture was the Kodak News Picture of 1991. The black and white version shown here was runner up in the Ilford Press Awards that same year. Photograph by Ken Lennox.

London, moved to the *Daily Star* as Picture Editor (but hated it) and went back again to the *Mirror*. Three years later, he went to *Today*, having been approached previously when the paper was first launched but having declined the financial package that was originally on offer. When he did move it was, he explains, 'because I wanted desperately to work in colour.' *Today* was the first British national newspaper to use colour pictures as a matter of routine.

Lennox is now Picture Editor of the *Sun*, Britain's biggest selling national daily. His advice to those hoping to break into press photography is to study the subject at college or to work on a small local newspaper. 'You've got a lot to learn,' he warns.

> You've got to be smart. The days of a journalist chewing gum are gone. You've got to be computer literate and you've got to be prepared to change all the time. You've got to be able to process your own film and print your own prints. You've got to be able to use a Mac properly. You've got to be able to transmit and receive pictures using a computer. But press photography hasn't changed: being a photojournalist is still about being a journalist with a camera. You've got to know what a story is and be able to show that.

As for the purity of photographs in the digital age, Lennox points out that picture manipulation has always been possible: all that computers have done is to make manipulation quicker and easier in many cases. 'You could always do lots of that, but it can't come into news pictures at all. You can do what you like with features pictures, but not with news. You must keep your news pictures pure, or else you have nothing.'

Jim Marks

Jim Marks studied to be a sculptor before turning to photography. For about a year, he assisted the likes of Patrick Lichfield and Bob Carlos Clarke, then he launched out on his own as a PR photographer.

> I'm a very ambitious person. I blagged the gear and opened as many accounts as I could. The first job I did was worth about £40 to me. I don't think the fee even covered the film, but I busted my gut to do it. With PR, you're often shooting on a shoestring budget to an impossible deadline. I always try to do something different – stuff that other people don't do. I do a lot of cross-processing and I've used the Fuji six-nine rangefinder for doing Formula 1 in the pits. Clients just love it when you slap a 6 × 9 cm transparency down when all the paps are using 35 mm Nikons and Canons with auto-TTL flash.

When on assignment for PR clients, Marks often works alongside celebrity press photographers, but he never sells his pictures to the papers. 'People use me because I don't sell to the press. I'm definitely more corporate than press. Once you flog a picture to a paper, you're down that road and some people won't use you any more.'

Figure 10.5 Cross-processed picture taken on the roof of a camper van. Photograph by Jim Marks.

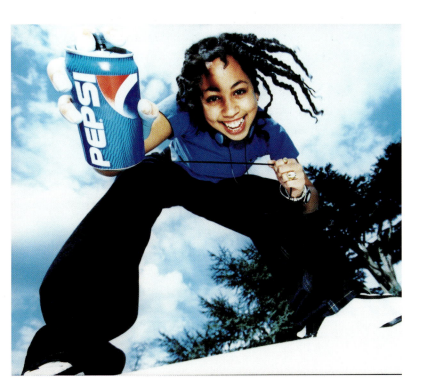

Although he has his own Web site, Marks is very definitely a film-based photographer. 'The Web is just another way of promoting yourself,' he points out.

Having spent seven years working for such clients as Club 18–30 Holidays, Lloyds Bank plc, Hewlett Packard and Pepsi Cola, Marks is now trying to concentrate more on taking the types of pictures that he wants to do. The next step in his career is therefore to find an agent to put him forward for advertising commissions.

Marks has two pieces of advice for newcomers to PR photography. At the outset, it is important to strike up a good relationship with a high-quality processing lab. 'It costs a lot of money to use the best people, but if you don't use the best people, you don't get the best pictures.' Later on, Marks predicts it will become apparent that there is only so far you can go in press and PR photography if you are really ambitious. 'The old phrase "man cannot live off editorial alone" is dead right,' he warns. 'Anybody can knock something off in an afternoon, but to get really good pictures takes a sensible budget – and that's something you don't very often get in PR photography. That's why I'm now moving more into fashion and advertising.'

Paul Stewart

When an IRA bomb rocked Canary Wharf and suspended work at the *Mirror*'s docklands headquarters in February 1996, it was Paul Stewart who set up an electronic picture desk at home to transmit images to the *Daily Record* in Scotland, where the *Mirror* was being printed while its London base was out of action. 'It suddenly occurred to me,' he recalls, 'that all BT's stuff about tele-working was true.'

Since that time, Stewart, who has worked regularly for the *Mirror* from the mid-1970s, has acquired an enormous amount of expertise in digital photography and picture delivery. Despite this, he owns only a relatively modest, fixed-lens digital camera: the bulk of Stewart's photographs are taken on film and are then scanned if necessary for electronic distribution.

When it comes to choosing a digital camera, 'be very careful about what equipment you buy,' he cautions, 'it isn't clever to have last year's model.' Rather than buying, Stewart recommends leasing equipment, ensuring that there is an option to upgrade as new models become available. Check the burst rate (the number of pictures that can be taken in quick succession) and the file size generated. 'Papers usually need something that is around 4–5 MB in the raw state, which converts to about 200–300 kB after compression. Eight MB is a big file for press work, and 15 MB is only very rarely needed – mostly by magazines.'

For picture transmission from the field, it is important to have a mobile telephone with fast data transmission capabilities (something that depends on both the equipment and the network used).

Figure 10.6 Reproduced here directly from a digital file (of a film negative), this is one of the Mirror's pictures that were transmitted to the Daily Record in Scotland after the Canary Wharf bombing. Photograph by Paul Stewart.

If you're going abroad, make sure you've got all the right adaptors. One pocket of my Mac bag is just full of phone adaptors. You've got to be very careful where you plug things in as well: if you plug a modem into what looks like a BT socket in Israel, it's liable to fry your equipment. There's a company called TeleAdapt that is the well kept secret of photographers who go abroad. It has all the adaptors and test equipment you need.

As far as computers and software are concerned, it is less important to have the very latest items.

For transmission, I've never found any software better than Microphone – it's still a good program despite being old, but I know a lot of people use the White Knight shareware program. For captioning, you need something that does IPTC (International Press Telecommunications Council) captioning. The old way of just writing credits and captions at the bottom of the picture is useless, because as soon as the image gets into the picture desk it gets cropped to fit the page and all that stuff is lost.

You also need a good scanner. The Nikon CoolScan-II is very good, but it's not the best. The big Minolta is great, but it's expensive. And the Minolta digital camera is one of the best going, but it can only do one frame every two seconds, so it's right out for press work. But all that could change tomorrow.

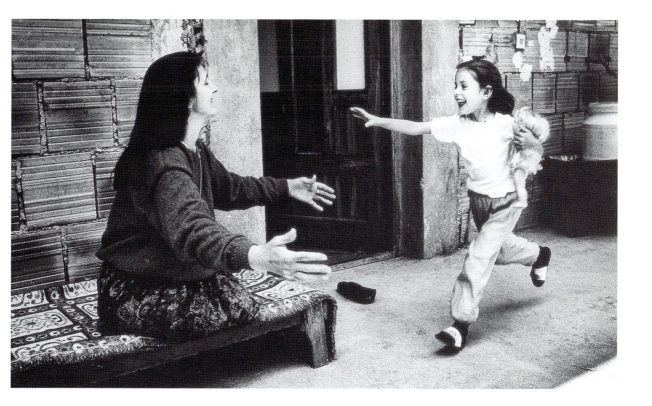

Tom Stoddart

Tom Stoddart originally wanted to be a reporter. He only applied for a job as a photographer because he hoped he would be able to shift direction once employed. 'Three days in, I knew I didn't want to any more. The writers just spent their time on the 'phone: photographers were out and about. I learned a lot then, not so much about photography as about dealing with people,' he recalls.

After four years, Stoddart left the Berwick Advertiser Group to join a York-based press agency run by John Pick. 'He taught me that there is a story and a picture in everything. He taught me how to scan local papers and turn stories into something that would be of interest to the nationals.' Stoddart went in the same direction and took a job at Express Newspapers working for the *Daily Star*, where he was one of the first photographers to cover the linking of Lady Diana Spencer to Prince Charles prior to their engagement. He later moved to *Today* before deciding to switch to magazine work. 'I wanted to have time to develop ideas. In newspapers, it's all go, go, go! In newspapers there is no time to explore the subject. It seemed to me a waste to be sent right around the

Figure 10.7 Winner of the Credit Foncier Award for the most positive news picture of 1995. Photograph by Tom Stoddart/IPG.

PROFESSIONAL PRESS,
EDITORIAL AND
PR PHOTOGRAPHY
■

world to spend just two days away then to be brought back because the paper had got bored of the story.'

Although by his own admission Stoddart is a black and white photographer, his assignments may be covered in either black and white or colour, depending on which will tell the story best. A strong adherence to black and white, and also unimaginative choices of subjects, are the two most common faults that he detects in the work of aspiring photojournalists.

> Students always seem to have pictures of people begging or living in cardboard boxes – and partly the colleges are to blame because everybody is always looking at pictures by Don McCullin. London is now 'Cool Britannia' but photographers aren't reflecting that. I'm not saying photographers shouldn't go out and shoot a gritty black and white story, but you can't survive on that as a young photographer.

Stoddart's advice to aspiring press photographers is to join a local paper or news agency and to concentrate on the basics.

> The best pictures come from your eye, not from the camera. It's about what is inside you. Whether you shoot on digital or whatever, your creativity is what makes you a good photographer. Don't go out and expose yourself to the highest levels too soon. Don't try to be a brain surgeon straight away. Learn what it takes to tell a story in pictures. Learn the skill of taking an ordinary story and making an extraordinary picture out of it. And you must be really dedicated: it's a really tough way to make a living today.

11 EPILOGUE

Photography is one of those things you cannot learn from books alone: you must go out and take pictures if any of what you have read is to be of real value. However, I do hope that the information given on the preceding pages will at some stage help you to overcome problems and so smooth your way in the business of photography.

In closing, I would like to thank all the people who have contributed to the making of this book in one way or another. First and foremost I would like thank Cedric Tarrant (no relation) and the photographers at the Cambridge Evening News who helped me during my very first days of taking press pictures. Amongst those photographers to whom I have spoken and who have freely given of their time and knowledge, I would especially like to thank Rod Ashford and Paul Stewart. I am also indebted to Terry Fincher, whose book *Creative Techniques in Photo-journalism* inspired and informed me in a way that I have tried to emulate for others here.

Finally, I would like to give particular thanks to three people. My uncle Bryan is the person who should take responsibility for the fact that this book exists at all, for it was he who helped me persuade my mother, many years ago, that I really did have to spend my entire savings on a camera rather than on anything else.

Larry Bartlett was, without doubt, the person who inspired me most when it came to improving and developing my photography. Larry always believed that it wasn't worth doing anything unless you did it to the very best of your ability – and, preferably, better than anybody else. If he were still alive today, I am sure he would have a few things to say about some of the prints that are included here!

My fiancee Lin, soon to be my wife, maintains that she is totally incapable of taking photographs, so to prove her wrong I have included one of her pictures in this book. Her hand can

PROFESSIONAL PRESS, EDITORIAL AND PR PHOTOGRAPHY

175

Figure 11.1 These are two of my favourite portraits, taken almost ten years apart, of two photographers whose pictures are used editorially yet who are not normally thought of as editorial photographers. Cornel Lucas has been photographing celebrities since the golden days of black and white Hollywood films: Bob Carlos Clarke is active in the same sort of arena now. Both have a definite and identifiable style – something that can greatly help a photographic career in the long term.

also been seen in other examples, particularly those of a more illustrative nature. One of Rod Ashford's comments made during our discussions was that photographic careers can break relationships, but that the right relationship can help to make a career a success. He was talking about his wife Sandra, and I would say the same thing of Lin. As well as bringing me great happiness, Lin has made me very much more visually aware than I ever was before, and I hope this is reflected in the pictures that I now take. Thank you Lin, for everything.

Figure 11.2

APPENDIX

Useful contacts

It ought to be a safe assumption that anybody who works in press, editorial and PR photography should be adept at researching addresses and telephone numbers. On this basis, there seems to be little point in listing mainstream suppliers of photographic equipment and materials – all of whose current details can be found in magazines and specialist directories. Local tax (Inland Revenue), social security (Contributions Agency) and VAT (Customs and Excise) offices' details can be found in the telephone directory. A few additional points of contact are listed here for convenience.

Addresses

Association of Photographers
81 Leonard Street
London EC2A 4QS
Tel: 0171 739 6669

National Union of Journalists
314 Gray's Inn Road
London WC1X 8DP
Tel: 0171 278 7916

Bureau of Freelance Photographers
497 Green Lanes
London N13 4BP
Tel: 0181 882 3315

British Journal of Photography
39 Earlham Street
London WC2H 9LD
Tel: 0171 306 7000

Publications

The ABC of UK Photographic Copyright, published by BPLC, available from the Association of Photographers (see address above).

Beyond the Lens: Rights, Ethics and Business Practice in Professional Photography, published by the Association of Photographers (see address above).

Big Book, a comprehensive annual directory of contacts, published by the British Journal of Photography (see address above).

Where to Study Photography, Film, Video and Television, the complete guide to full-time and part-time photographic courses, published by the British Journal of Photography (see address above).

Digital Imaging for Photographers, by Adrian Davies and Phil Fennessy, published by Focal Press. An accompanying CD-ROM is also available.

Awards

Nikon UK (Nikon Press Awards)
380 Richmond Road
Kingston
Surrey KT2 5PR
Tel: 0181 541 4440

World Press Photo Foundation
Jacob Obrechtstraat 26
1071 KM Amsterdam
The Netherlands
Tel: 00 31 20 6766 096

Specialist equipment

Photographic safes:
Boxx Security
31a Oxford Street
High Wycombe
Buckinghamshire HP11 2DJ
Tel: 01494 558181

Mini-coves:
Colorama Photodisplay
Unit 7, Ace Business Park
Mackadown Road
Kitts Green
Birmingham B33 0LD
Tel: 0121 783 9931

Non-standard Polaroid film backs:
GW Associates
Unit K3, Cherrycourt Way
Stanbridge Road
Leighton Buzzard
Bedfordshire LU7 8UH
Tel: 01525 850911

Radio slave flash triggers:
Systems Imaging
Unit 15, Oakwood Business Park
Stephenson Road West
Clacton-on-Sea
Essex CO15 4TL
Tel: 01255 433390

Lumedyne portable flash systems:
The Flash Centre
54 The Brunswick Centre
Bernard Street
London WC1N 1AE
Tel: 0171 837 6163

Quantum batteries:
Hasselblad UK
York House, Empire Way
Wembley
Middlesex HA9 0QQ
Tel: 0181 903 3435

Telephone connectors:
TeleAdapt
Technology Park
Colingdeep Lane
London NW9 6TA
Tel: 0181 233 3000

Business cards:
Graham & Sons (Printers) Ltd
51 Gortin Road
Omagh
Co. Tyrone
N. Ireland BT79 9HZ
Tel: 01662 249222

Digital equipment:
John Blishen & Co Ltd
75 Kilburn Lane
London W10 4AW
Tel: 0181 969 0071

INDEX

184